DRAWING
Family Portraits
A guide to creating memorable artworks

PETER GRAY

ARCTURUS

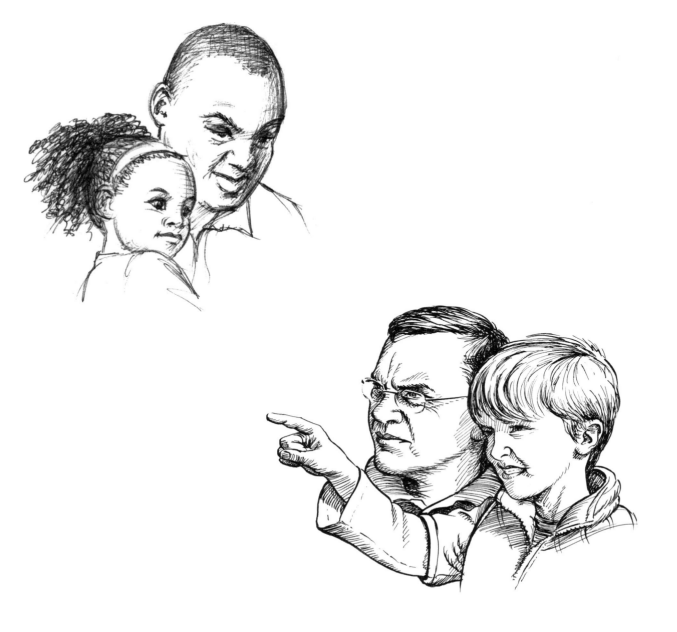

ARCTURUS

This edition published in 2014 by Arcturus Publishing Limited
26/27 Bickels Yard, 151–153 Bermondsey Street,
London SE1 3HA

Copyright © Arcturus Holdings Limited/Peter Gray

ISBN: 978-1-78404-047-5
AD004131UK

Printed in China

Contents

Introduction

As newborn babies, the first things we recognize by sight are faces. As soon as a baby can focus, she will instinctively hold eye contact with the faces that loom over her crib. Soon she will learn to read facial expressions, the first communication she understands, and she will continue throughout her whole life to seek those essential clues which signal the acceptance, satisfaction or displeasure of the people who make up her world.

Throughout history, the portrait has been a mainstay of artistic tradition. From Ancient Egypt, through Greek and Roman civilizations, the Middle Ages and the Renaissance onwards, artists have depicted the heroes, rulers and nobility of their times. The lucrative careers of Old Masters such as Holbein, Rembrandt, Gainsborough, Reynolds and many others were built around portraiture. Centuries later we still revere their skill in bringing the illusion of life to the canvas and we remain intrigued by the long-dead faces which peer back at us from within the frames.

There is no subject more interesting to people than people – so it is not surprising that we are drawn to draw them. And it is quite natural that we should want to draw the people we know and love best – our families. It is also convenient if they are near at hand, unthreatened by our interest in them and patient enough to sit still for their fine features to be recorded for posterity.

Drawing portraits is not the easiest of artistic pursuits: if you draw a tree, few viewers will compare your drawing to the precise dimensions of the particular tree you have drawn. Yet even the least visually literate viewer will feel qualified to judge whether you have captured a likeness, and you will generally be your own sternest critic. You must harden yourself to such judgement. The important thing is to draw lots of portraits with the aim initially

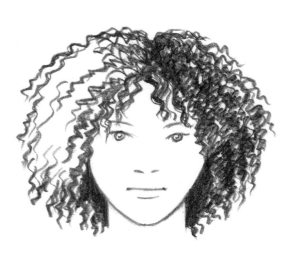

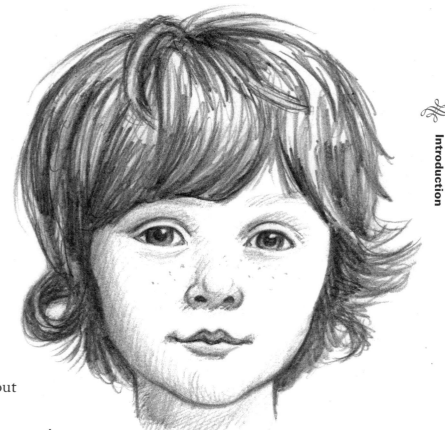

of making drawings that look convincing as real people. If you stick with it, it should not take too long before likenesses emerge out of your many mistakes and failures.

Wherever possible, especially when you are starting out, draw from life. Make your model comfortable, and maybe switch on the radio or television to keep him/her entertained while you work. Much more may be gained from making many quick drawings or 'studies' than slaving away over the same 'masterpiece' for hours on end. There's no surer way to lose interest in drawing or test the patience of your subject.

As you get more ambitious it may be practical to work from photographs to draw large family groups, capture fleeting expressions or develop caricatures. Using photographs is fine, but always remember this golden rule: you are not a camera and a drawing is not a photograph! If you aim to set down every hair and wrinkle, every subtle modulation of shade, you will succeed only in making dull drawings and driving yourself mad. A simple, intelligent, selective approach will bring out the best in your drawing and in your subjects. That's what I hope to convey through this book: how to draw family portraits that have impact, character, and charm, to raise the aspirations above the level of mere 'snapshots', and most of all to make the whole process satisfying and rewarding for you and your family.

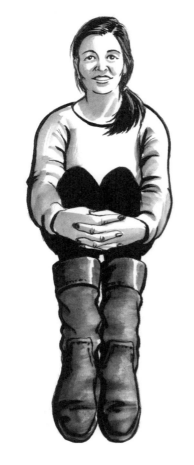

Basic materials and equipment

The most important item of equipment for any drawing is your brain. That's the organ you draw with – the hand is merely the brain's servant, the eye its messenger. With your brain engaged you can make perfectly good drawings with a scratchy old biro, a stick dipped in coffee or your finger in wet mud. But it would, admittedly, be more practical to start with a pencil. That's pretty much all you need to learn the essential skills of portraiture. Throughout the book I'll introduce other materials that can be used for certain effects, drawing styles or experimental play, but for now we'll stick with pencils.

Pencils

Although any old pencil will do the job, cheap office pencils can be scratchy and unsatisfying, so it's worth equipping yourself with two or three decent artists' quality pencils from an art shop. You'll need a hard pencil, say H or 2H for guidelines and under-drawing, a general drawing pencil, B or 2B, and a nice soft, dark pencil such as a 4B.

The H stands for 'hard'. These pencils make faint marks and the higher the number the harder the graphite. B stands for 'black'. Such pencils are also known as soft pencils and make richer, blacker marks, increasing in softness with the number prefix.

Sharpening

There will be times when blunted pencils can be used to good effect, but generally you should strive to keep your pencils sharp. For convenience, it's hard to beat a simple pencil sharpener, so long as the blade is not too dull. It's more satisfying, however, to use a sharp knife or scalpel to whittle the points of your pencils. A knife also gives you the option to shape a longer tip, exposing more graphite, which can be useful for various shading techniques.

Erasers

Even if you're a genius who never makes mistakes, you'll need an eraser. Erasers are essential for rubbing out guidelines, correcting errors and lifting out highlights. There are many different types available, but there's no need to get technical about them as they all do basically the same job. If you buy one from an art shop it should be of good enough quality for any demands you make on it.

Paper

Small fortunes can be spent on artists' quality papers and sketchbooks, but there's generally no need to break the bank. For your earlier attempts it is more liberating to use any cheap paper – indeed many of the illustrations in this book were done on mere office paper. For more ambitious artworks, it will benefit you to use better-quality paper that can be bought in single sheets or pads from an art shop. If you favour a smooth, detailed finish, go for smooth paper. Rougher, textured paper is often a good choice for drawings with heavy shading and vigorous mark-making. If you intend to use any wet media, such as watersoluble pencils or ink washes, heavyweight paper is an obvious choice to avoid buckling.

It is good practice to keep a working sketchbook on the go, for casual sketching and jotting down rough ideas. Such a book encourages you to draw regularly and provides a fascinating record of your rapid progress. I recommend a hard-backed, book-bound sketchbook of manageable size, such as A4 (21 × 30cm/8¼ × 11¾in).

CHAPTER ONE

The Head in Profile

Before we can get into the enjoyable business of making portrait drawings it would seem sensible to familiarize ourselves with the construction of the head. Heads can be complicated things to draw, so we'll start with the simplest angle of view, the side view or 'profile'. It goes without saying that every head is different, but there are certain aspects of proportion that are more or less common to all. Here follows a diagrammatic study of a 'standard' head.

Step 1

The adult profile can be thought of as fitting quite neatly into a square. It's helpful to divide the square into quarters. The dome of the head occupies the entire top half of the square.

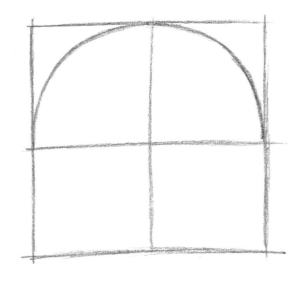

Step 2

Draw one guideline just above the mid-line and another slightly higher than halfway up the lower square. You can now follow the grid to add the nose and jawline, shown here as a male profile.

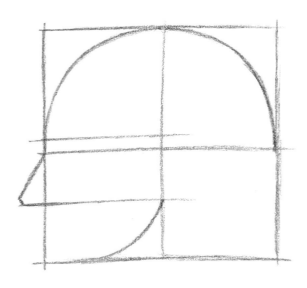

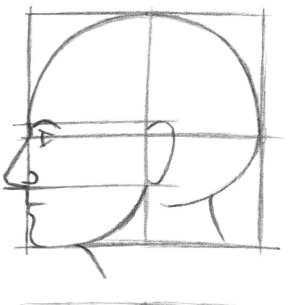

Step 3

There are three points to note when placing the eye: it sits halfway down the head, far lower than is often imagined; it is almost at the front edge of the head; and it is triangular in shape from this angle of view. The eyebrow sits just above the eye, level with the upper edge of the ear. The lower extent of the ear is level with the base of the nose and the ear sits behind the vertical halfway line, further back than you may think. It's also worth noting that the neck meets the head at a sloping angle.

Exactly the same proportions can be observed in the female profile, although there are some slight differences in the overall contours. The female forehead is more rounded and sits further forwards, whereas the male's slopes backwards somewhat. There is usually more of a pronounced slope to the lower face and the neck will be thinner. Individual features typically differ too: the nose is more delicate, the eye a touch larger and lips are often fuller.

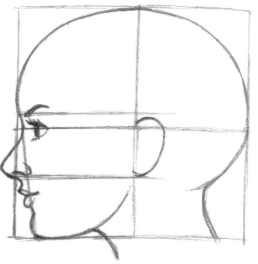

Students of the human figure practise life drawing to develop an understanding of the body's form without clothing, which informs their interpretations of clothed figures. Similarly, it is a good idea for you as a budding portraitist to familiarize yourself with what lies beneath the surface of your subject. In studying the skull we can see where areas of hard bone affect the form of the face and head. From this profile view, the more noticeable areas are the brow, the bridge of the nose and the chin. As you move on to more detailed profile drawing, the cheekbone will also become important. Other parts of the face – the cheeks, jaw-line, lips and so on – tend to be fleshier and can therefore be drawn with softer marks.

Step 1

In practice, one would not usually approach drawing a profile within a rigid box. It is more practical and takes less effort to start with a rough circle and the approximate mass of the lower face. Feel free to add any construction lines you find helpful; they can always be erased later.

Step 2

To draw this young man, I studied his features carefully and roughly sketched them over my guidelines. I would usually do this quite faintly with a hard pencil, although I have drawn more heavily here for the sake of clarity. Note how the hair stands proud of the upper head.

Step 3

With the features reasonably well positioned, I could then erase my guidelines and start to refine the drawing, always paying close attention to the model. I noticed that I had made the head too slim, so I extended the back of it.

Step 4

From then on, it was simply a case of firming up the outlines with a softer pencil and adding the extra details. Don't worry too much about detailed hair textures for now; the hair can be treated as a mass of certain size and shape. Use the corner of an eraser to clean up any errant marks.

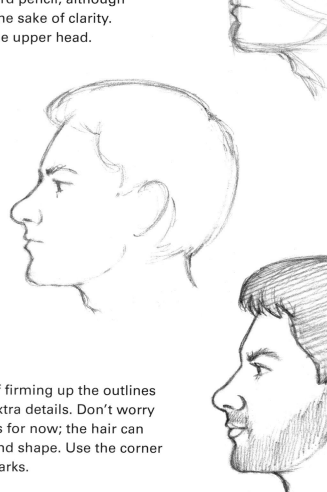

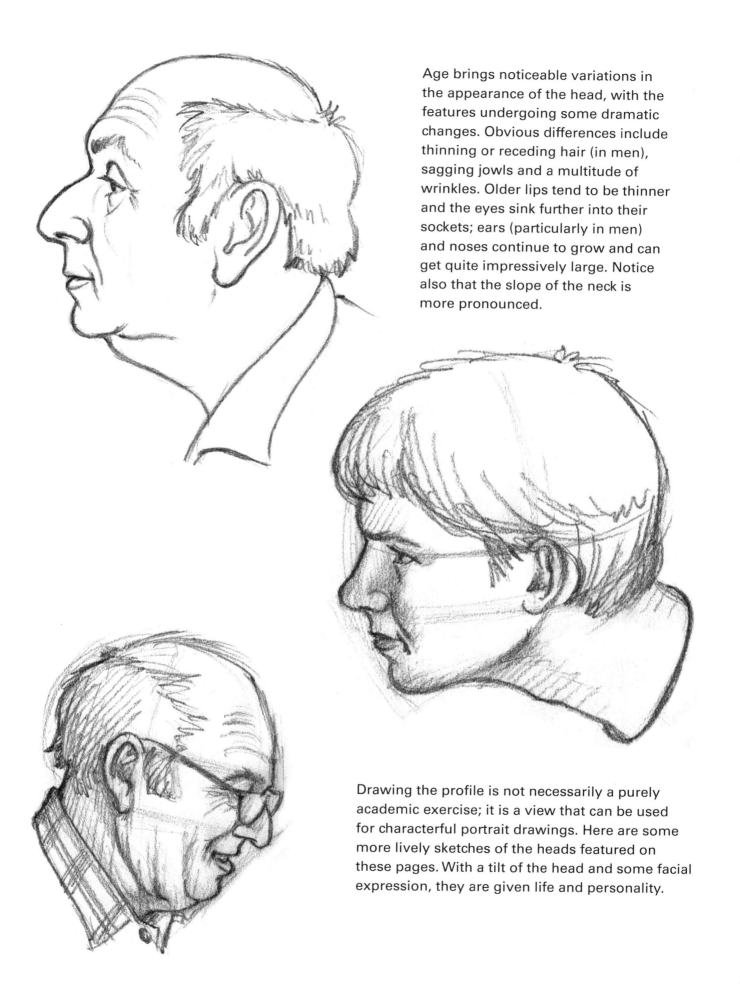

Age brings noticeable variations in the appearance of the head, with the features undergoing some dramatic changes. Obvious differences include thinning or receding hair (in men), sagging jowls and a multitude of wrinkles. Older lips tend to be thinner and the eyes sink further into their sockets; ears (particularly in men) and noses continue to grow and can get quite impressively large. Notice also that the slope of the neck is more pronounced.

Drawing the profile is not necessarily a purely academic exercise; it is a view that can be used for characterful portrait drawings. Here are some more lively sketches of the heads featured on these pages. With a tilt of the head and some facial expression, they are given life and personality.

If you are to draw a child, you will find that the overall shape of the head is not so deep as an adult's and the whole head and face fits inside the imaginary square. The face occupies less space, with the eye sitting well below the halfway line. Noses are very much smaller and less distinctive in shape. Eyes are relatively much larger than those of adults and the ear sits yet further back on the head.

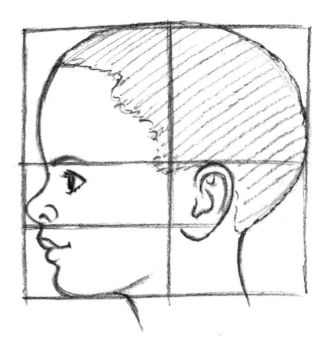

Here are five members of the same family at ages five, seven, nine and adult. You can see how the proportions and features develop from youth into adulthood and how very much smaller the younger heads are compared with those of their parents.

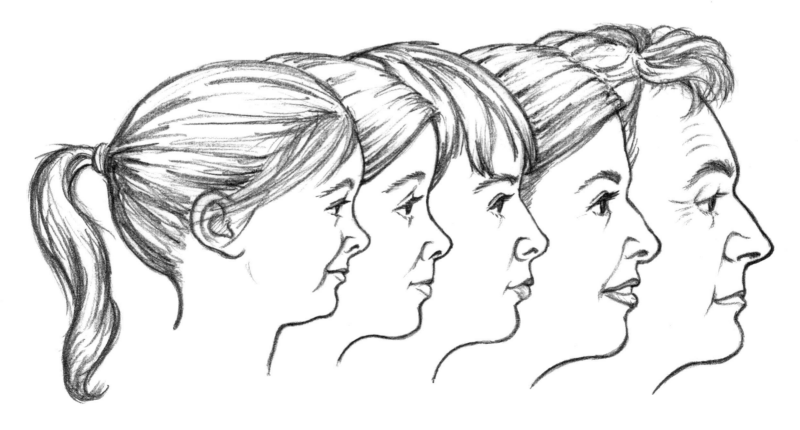

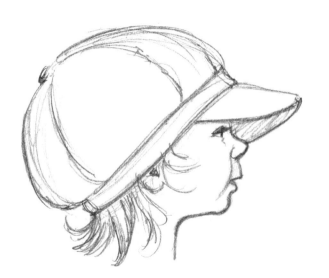

As we progress through this book we'll take on lighting, shading, mark-making and more sophisticated viewpoints. Yet even at this early stage in our discussion of portraiture, dealing with mere line drawings in profile, it is possible to create portraits that have sensitivity and visual impact. An interesting accessory can bring an extra dimension to a portrait drawing. This small child's tiny face is accentuated by the oversized hat, which engulfs her.

A long, elegant neck makes for an arresting portrait feature. Having the model tie her hair up allows a clear view of her neck; the upward tilt of her head extends the neck yet further.

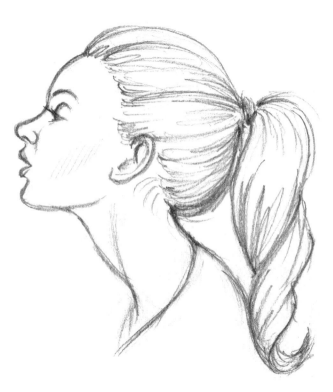

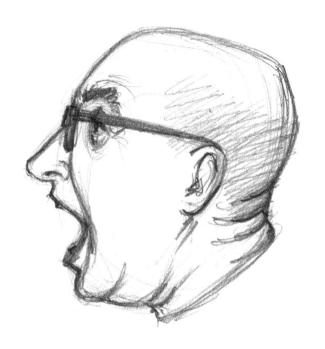

An exaggerated facial expression often makes for an interesting portrait. It would be uncomfortable for someone to hold an expression like this for any length of time, but the speed with which a profile can be drawn means you can be a little more demanding of your models.

The Head in Front View

The front of the face is a more familiar view and one that brings with it more complexity than the profiles we have seen so far. Here there is the need to draw with a degree of symmetry, which is not always as easy as it seems. You may also need to reappraise your preconceptions of the proportions of the head. Again, some basic guidelines can help.

When my young daughters draw portraits, their emphasis is very much on the face rather than the head as a whole, and they tend to place the eyes very high on the head. Mouths are greatly exaggerated while other features, such as ears and neck, are entirely absent and there is no understanding of the shape of the face. Of course, these are children's drawings, but adults are often guilty of similar errors of perception. We must continually remind ourselves to look at any subject with a fresh, unbiased eye in case familiarity clouds our judgement.

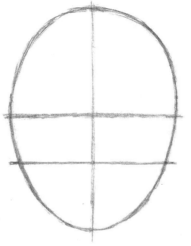

For a front view, the head can be thought of as an inverted egg shape. A vertical line down the centre helps to get the basic shape and place the features of the face symmetrically. As we saw when drawing profiles, the eyes sit about halfway down the head – a horizontal guideline will assist their positioning. Another horizontal line, just a bit higher than the mid-point of the face, will guide the base of the nose.

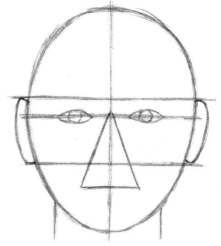

The levels of other features are as you would expect from the profile view: the brows just above the eyeline, level with the tops of the ears, which extend to the base of the nose. The eyeline can be divided into five sections, with an equal width for each eye, the space in between and the spaces each side. The base of the nose is about an eye's width. A triangle from the eyeline passing either side of the base of the nose is a guide to the mouth width.

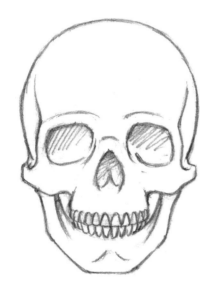

Looking at the skull from the front helps us to appreciate the hollows and ridges that underlie the face. Here we can see the bony protrusions that form the brows, cheekbones, chin and jaw-line, as well as the hollows around the eyes and under the cheekbones. Despite the great varieties of face types, skulls are surprisingly uniform.

Although men's heads may be larger than women's, the relative proportions of the head seen from the front are generally the same. The facial features, on the other hand, differ considerably. Women's eyes tend to be larger than men's and their eyebrows are less bushy. Men's faces may be generally broader and the jawlines heavier, with wider chins. Women's lips are often fuller than men's and their noses are usually smaller.

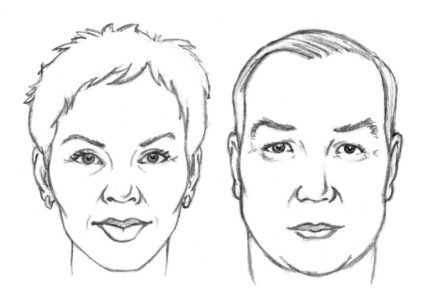

Self portraits

To practise drawing the face from the front, you won't find a more willing model than yourself. Sit comfortably in front of a mirror and position your drawing board or sketchpad so that you do not need to move your head too much.

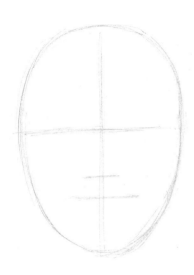

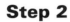

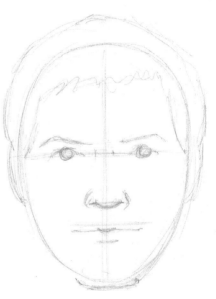

Step 1

Start with the basic egg shape, with the eyeline and rough positions for the nose and mouth. The precise proportions do not matter for now; it's just a question of getting something down on paper at this stage.

Step 2

Drawing lightly with a hard pencil, roughly copy the broad shapes and sizes of your features on to the egg shape, paying particular attention to the spaces in between. Keep everything very loose and sketchy.

Step 3

Now start to look more closely at your reflection as you gradually hone the shape of the features. Work on the outlines of your lower face and jaw – a very distinctive element of character. Some of your more obvious character lines, such as those around the mouth and under the eyes, should also be drawn in lightly.

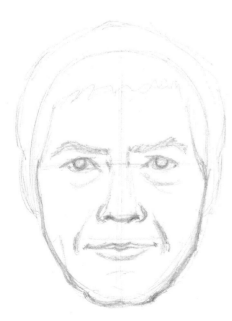

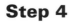

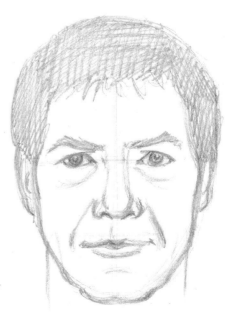

Step 4

Adding some rough shading will help you to see how a likeness is shaping up. At this stage, if anything is looking seriously astray, erase it completely and draw it again.

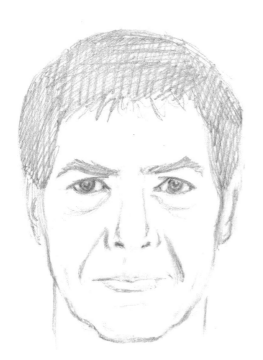

Step 5

With a rough likeness achieved, it's a good time to erase your guidelines and mistakes and soften some of the parts you may have worked very heavily. Use the corner of your eraser and work carefully around the features; you don't want to erase your well-drawn elements.

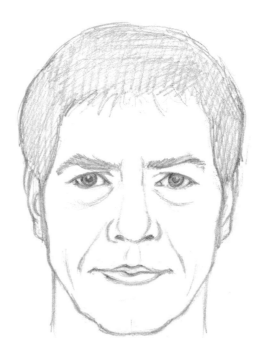

Step 6

Still working with a hard pencil, set down your definitive outlines, continuing to look carefully at your reflection in the mirror.

Step 7

With a softer pencil (I've used a 2B), add definition to the darker parts: the eyes, lashes, brows, nostrils, the line between the lips and so on. If you have dark hair you may like to darken it in your drawing, but don't worry about the texture; for now the hair can be a simple shaded shape.

Perhaps you will manage to achieve a good likeness at the first sitting, or perhaps, like mine, it will be a little astray. That doesn't really matter at this stage – the important thing is that you are getting used to the process of drawing the portraits and gaining familiarity with the proportions of the head.

Youthful head proportions

Step 1

There are noticeable differences of proportion between the standard adult head and that of a child. With a child, the initial egg shape is a little wider, but within that shape the first guidelines are the same. The difference is that the centre line, mid-way down the face, marks the line of the brow, as the eyes are quite a lot lower down on a child's head.

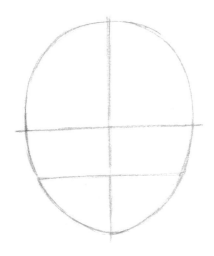

Step 2

Compare this diagram with the adult version on page 17. You will see that the eyes are not only lower on the head, but also noticeably larger in relation to the overall head size. The nose and mouth are relatively small and the ears are set lower. The top of the ears is roughly level with the eyes and the bottom is roughly level with the top of the upper lip.

The differences between the sexes are not discernible in the proportions and features of children's faces. This is a fairly accurate drawing of a friend's five-year-old child. From the features and face shape, and with a non gender-specific hairstyle, it is a matter of guesswork as to whether it is a boy or a girl. In the flesh, there is no doubt that this is a boy, and that is something you would naturally strive to bring out in a portrait, with the hairstyle, clothing, expression and so on.

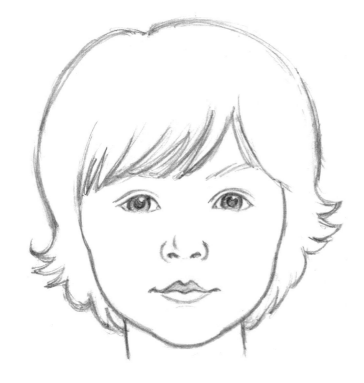

Newborn babies' eyes are set even lower beneath the head's centre line, sitting around two-fifths up from the chin. The eyes, though still around a fifth each of the overall width, appear much larger because of the size of their irises and pupils in relation to the rest of the face. The outline shape of a young baby's face is typically ill-defined and rounded.

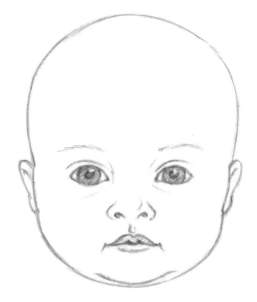

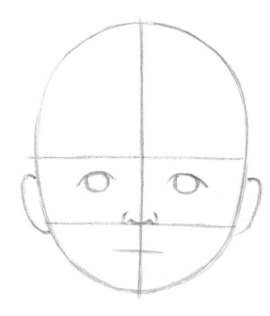

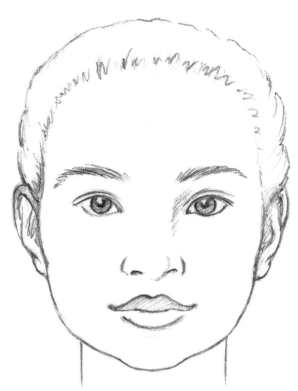

By the age of about 12 or 13, children's heads become more like adults in their proportions, though their eyes sit just below the centre line. But their features retain childlike qualities and a general roundedness that is lost in adulthood. The eyes are still quite large in relation to the overall head.

Shading

Drawing faces from the front provides much information about a person's likeness, but using mere lines will only get us so far. The head is a rounded three-dimensional object with many ridges and crevices that can only be revealed by the fall of light. With most drawing materials, we cannot draw light, but we can indicate its presence by drawing the shade and shadows where the light does not reach. Shading, or 'tone' to use the technical word, is not especially difficult, but it does require some close observation, a degree of logical analysis and a lightness of touch. It also helps to undertake it with a clear technique. Here is a demonstration of a commonly used technique known as 'cross-hatching'.

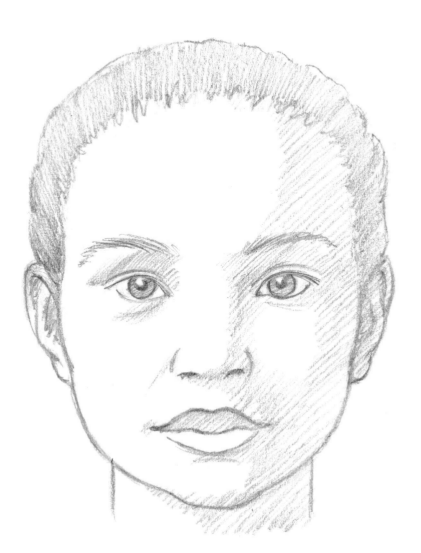

Step 1

This young girl's skin is quite dark, but it is common practice to ignore skin colour and concentrate merely on the fall of shadow on the face, otherwise dark, lifeless drawings can result. I started the shading by identifying the broad areas of shadow on her face; these were along the right-hand side because the light was coming from a window to the left. For this first stage, I shaded the darker areas using light strokes of a B pencil, all evenly spaced and running in a single direction. This is called hatching. For the hair I used more pressure and worked in the direction of the hair's flow (it was tied back behind her head).

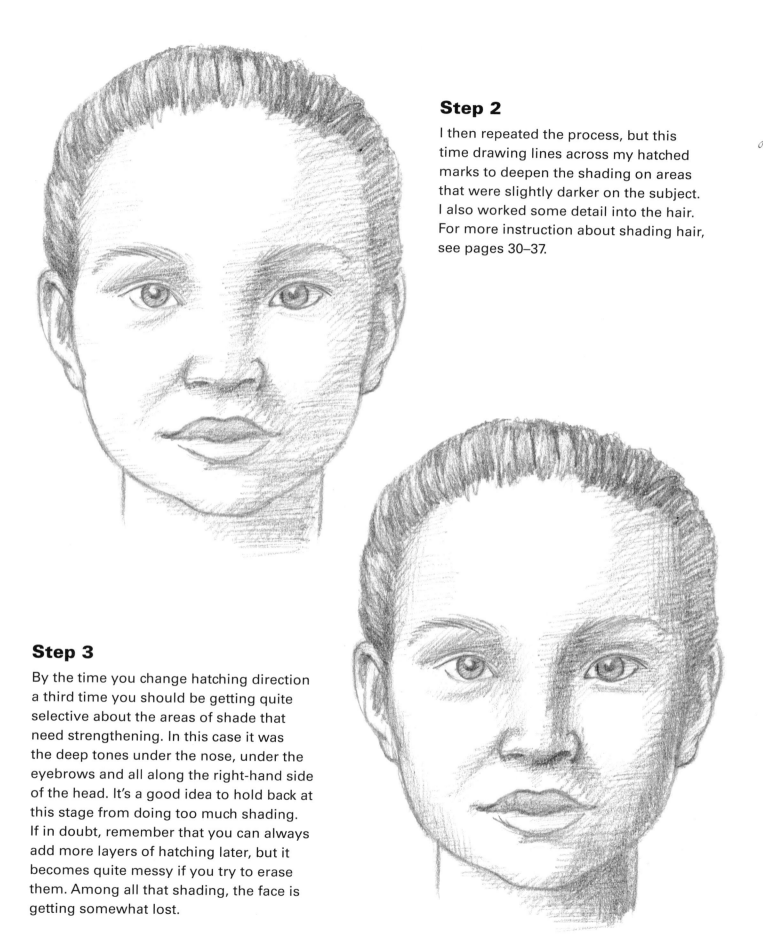

Step 2

I then repeated the process, but this time drawing lines across my hatched marks to deepen the shading on areas that were slightly darker on the subject. I also worked some detail into the hair. For more instruction about shading hair, see pages 30–37.

Step 3

By the time you change hatching direction a third time you should be getting quite selective about the areas of shade that need strengthening. In this case it was the deep tones under the nose, under the eyebrows and all along the right-hand side of the head. It's a good idea to hold back at this stage from doing too much shading. If in doubt, remember that you can always add more layers of hatching later, but it becomes quite messy if you try to erase them. Among all that shading, the face is getting somewhat lost.

Step 4

So, to bring the detail back out, I switched to a softer pencil (4B) and re-established the features – the eyebrows, eyes, mouth and so on. I also added more weight and detail to the hair.

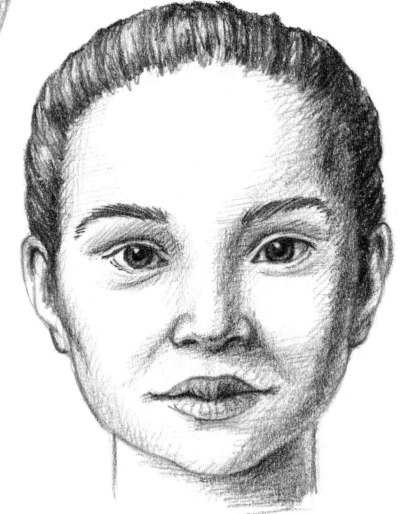

Step 5

By now the first layers of hatching, which probably seemed quite dark at first, appear quite subtle as befits a pretty, delicate model such as this. At this stage, refrain from doing too much more. Look carefully at your model. Try squinting your eyes as you look at the subject, and then as you look at your picture; it may help you to see where the shading needs beefing up here and there. I continued with my 4B pencil and hatched in yet another direction to bring out the dark line of shade around the side of her head and to further define the eyes, nose, mouth and hair.

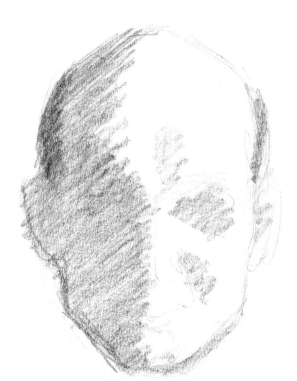

Step 1

Here is a very different approach to shading, much looser and more expressive and working in an opposite sequence – shading followed by drawing. To start with, I did an extremely rough and faint sketch of the face. Then I used the edge of a soft pencil, holding it at a shallow angle to the paper to shade the broad areas on this dramatically side-lit face.

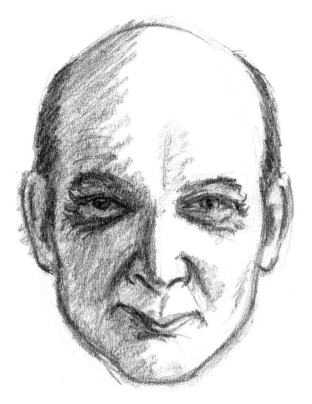

Step 2

For a second layer of shading, I continued with the side of the pencil, pressing harder to deepen the shading on the darker areas around the eyes and hair, and drawing in rough detail.

Step 3

I then used the point of the soft pencil to firm up the features in sharper detail. Instead of cleaning up the rough shading marks around the edges I prefer to leave them, as they add to the loose, rough-and-ready feel.

There are endless different styles and approaches to shading in pencil and various other drawing materials, many of which will be explored throughout this book.

A group portrait

When you are drawing two or more people together, your concerns extend beyond capturing the likenesses of the individuals; you also need to consider their relative sizes and positioning. Aim for consistency in the manner in which they are drawn, in terms of the marks that you make, the direction and quality of the light and so on. For this demonstration I have chosen a typical family group of husband, wife and young child.

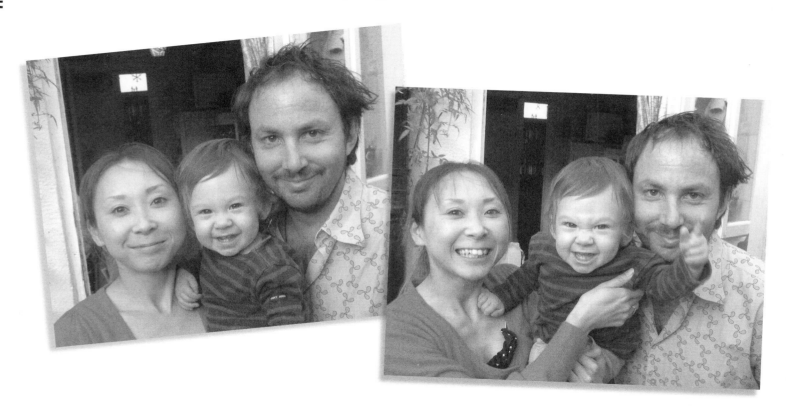

Although it's more rewarding to work from life, it's not necessarily practical. People have busy lives and cannot always spare the time to pose for a long stretch, and children in particular lose interest quickly. So for this demonstration, I took some photographs to work from. Whenever possible, take more than one shot to provide a range of angles, expressions and gestures. Try to get your subjects as close together as possible, to make for a nice compact grouping. But don't be too forceful in your directions; the group should look comfortably arranged. Always remain open to any spontaneous expressions or actions which can give your drawing that extra ingredient of character.

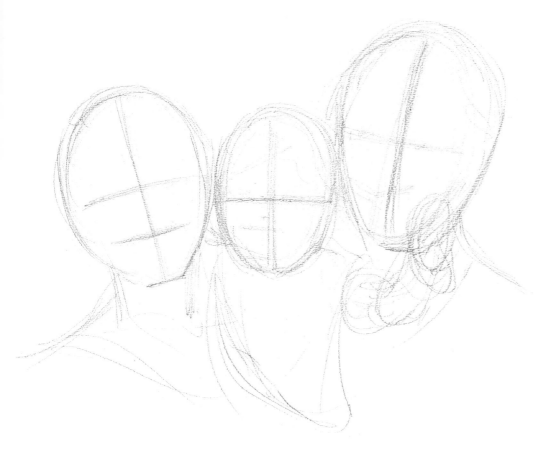

Step 1

Although I liked the close grouping of my first reference photograph, the man is somewhat taller than the woman, which makes for a slightly awkward imbalance. So, when drafting out the rough head shapes, I placed him lower down on the page. I also sketched in the rough sizes of the heads and some simple guidelines.

Step 2

Working with an HB pencil, I roughly drew the main features, face shapes and hair. The important thing is to keep everything quite light and loose at this stage and let the detail sharpen gradually.

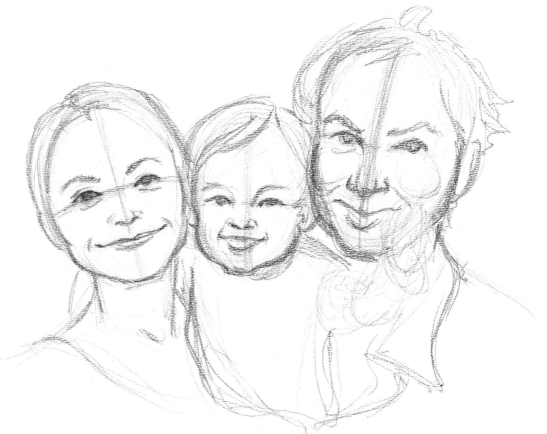

Step 3

Taking a good look at the drawing, I could see that the proportions of the mother's and child's faces were wrong. I erased the mother's eyes and redrew them higher up; then I erased the boy's lower face and redrew that too. It is important to make necessary changes to proportions and features at this point, before the paper is too heavily marked. I added detail to the ears and hair and drew the boy's outstretched arm. Then I used the corner of the eraser to remove guidelines and mistakes.

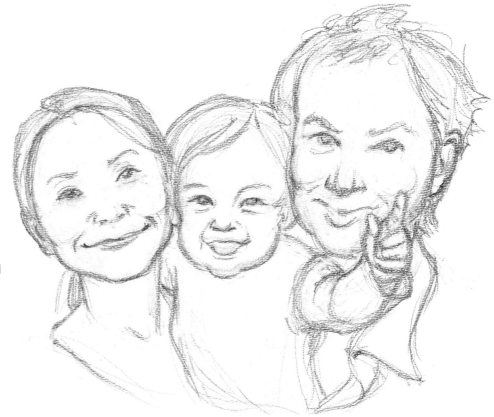

Step 4

Still using my HB pencil, I added some gentle shading to the darker areas around the faces, which immediately gave them some solidity and roundedness. I also added some shading to the hair and to the dark shapes between the heads. Some more detail around the eyes and mouths further established the characters.

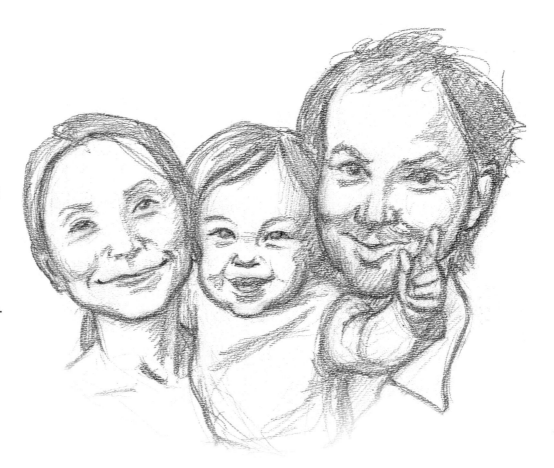

Step 5

For the last stage I switched to a softer pencil, a 2B. First I worked on the very darkest areas – the eyes, the darker parts of the hair and the shadows between the heads. As I did so, I paid close attention to my photographs. I moved my attention to the lighter areas and softened the transitions of tone on the faces, using an eraser. It was then easy to draw more definition into the mid-tone features, such as the noses and texture of the hair, as I was now confident with the degree of shading required for them. I left the boy's shirt white so as not to distract from the faces and make the drawing too heavy. I erased odd marks around the edges and firmed up the outlines of the collar to enhance the compactness of the grouping.

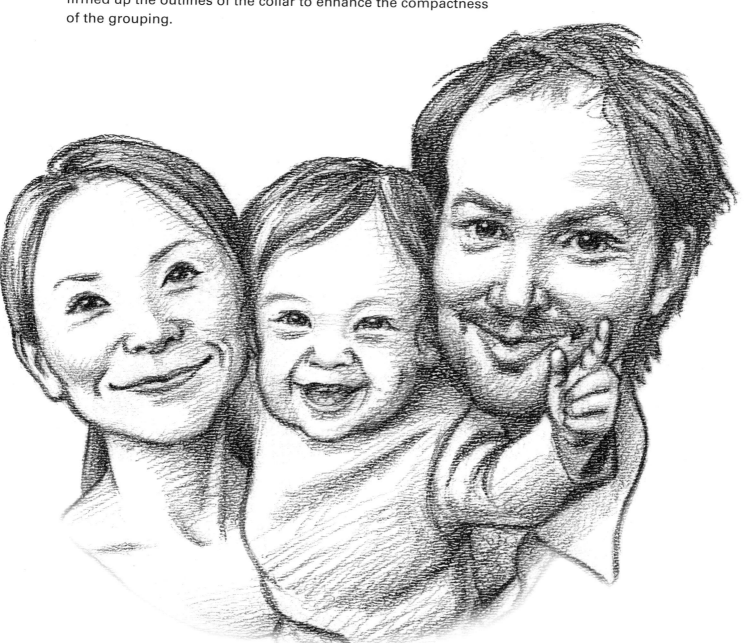

Drawing hair

At first glance, drawing hair may seem an unimportant feature of a portrait compared with all the other challenges. But hair is a very important part of a person's image. Hairstyles, colours and textures are remarkably varied and individual; in many cases, a hairstyle alone can be enough to identify a person. Although hair can be very complicated, it can usually be drawn quite simply. The important things are the overall size and shape, what fashion designers would call the 'silhouette'. Then we need to think about the texture, shine and degree of darkness. Over the next few pages we'll examine just a few types of hairstyle and how to approach drawing the typical features found on most heads.

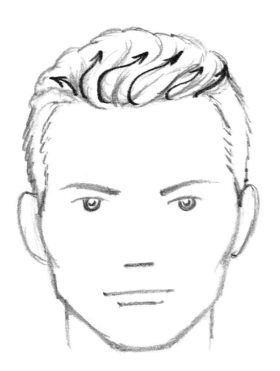

With short hair swept up off the forehead, we can clearly see the hairline – the shape above and around the forehead where hair growth begins. Levels of hairline can vary, particularly among men, and it's helpful to identify the level of a subject's hairline before you draw the hair. The wavy hair here curves back away from the hairline, over the top of the head. At the sides, the hairstyle follows the shape of the head. Some short textural marks indicate cropped hair.

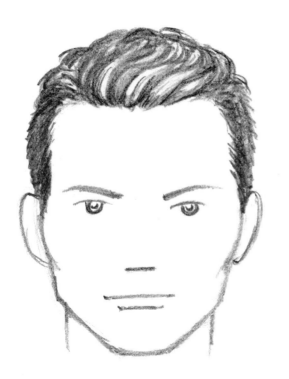

The main outlines are usually sufficient to describe the style and texture of the hair, so you need not work too hard on the shading. Keep it simple, because it is easy to get carried away and make the hair look laboured and heavy. Here I shaded the sides of the hair in the uniform dark mark of a soft pencil. For the top of the head, I worked some dark shadow around the main waves and left the waves themselves quite pale, so that they stood out against the dark.

Here the hair at the sides is longer and curves around the sides of the head, requiring longer marks rather than the short strokes used for cropped hair. The hair on top is allowed to fall loosely over the forehead. Individual hairs, even when short, naturally group together, in this case forming curved shapes that stand up and fall away from the head. Identifying these smaller masses of hair is half the battle when drawing hair.

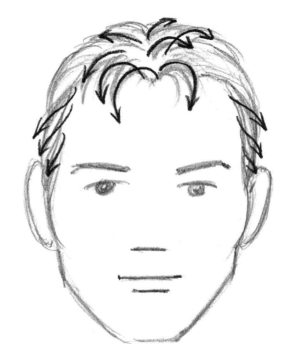

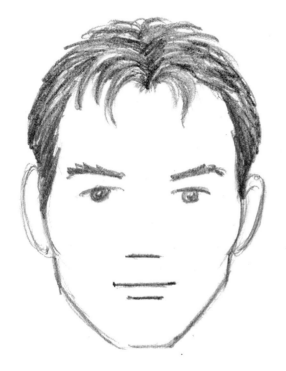

Again the shading on the hair is darkest where it is closest to the head. This is the general rule. The tufts of hair that stand up from the head catch the most light and should be left relatively unshaded, but the spaces in between, where the shadow falls, should be shaded more heavily.

Very curly hair grows out from the head, again making the hairline clearly visible. Hair like this is very structural and can be drawn initially as little more than a textured outline.

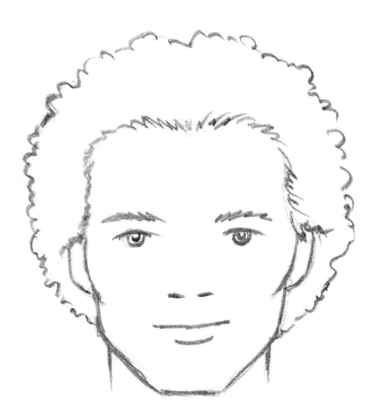

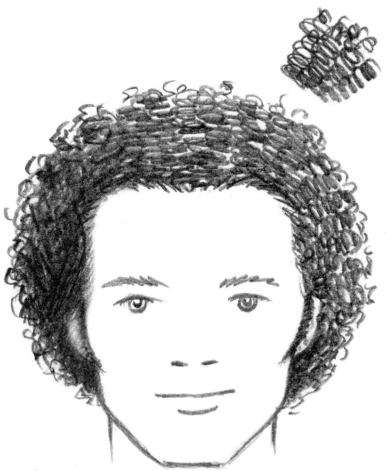

It would drive you mad to attempt to draw every precise curl in this type of hair! Much effort can be spared by simply using the right kinds of marks. I shaded the hair using a series of spiralling curls radiating from the hairline. You can capture the rounded form of the hairstyle by drawing more heavily on the shadier parts. Here, the light is coming from above right, so the hair is darker on the undersides, beneath the ears and on the left of the head. Adding wispy marks around the outside also helps to convey the hair's texture.

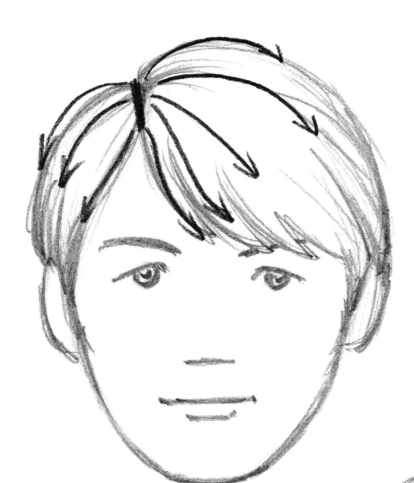

Longer hair will usually fall or be combed into a parting. Here you can see how the hair flows away from the parting and curves around the shape of the head. The various directions and curves in which hair flows are very important when it comes to drawing a hairstyle convincingly.

Shading these longer strands requires that you leave some of the hair quite white, to capture its sheen. Again, the shade is darkest where the hair meets the head at the parting; the marks should curve away from the parting, following the direction of the hair's growth. The hair will also tend to be darker at the ends, but leave the spaces in between quite pale, marked only by a few directional strokes.

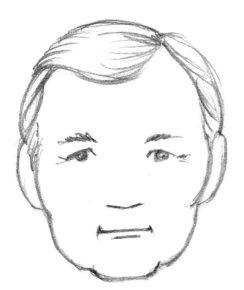

A receding hairline sits very much higher on the head and further back at the sides. The hair here is quite long, but relatively thin. It is swept back at the sides and curves down over the forehead before retreating back over the head.

Grey or white hair does not have the same degree of lustre as younger hair. So its shading should involve less tonal contrast, which effectively means that the shadowed parts are relatively pale. Older hair is often quite fluffy in texture, so it should be shaded with softer marks and less defined outlines.

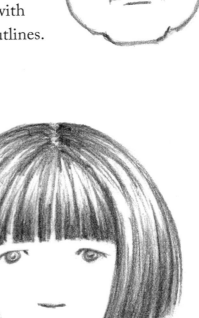

Women's hairstyles are often arranged in strong, definite shapes, which you should aim to capture accurately. Here, the hair flows from a precise centre parting and ends in a carefully clipped fringe and bob. Firm guidelines will help you to draw the length of the hair neatly, but then the effect can be softened if you let some of the strands cluster and separate.

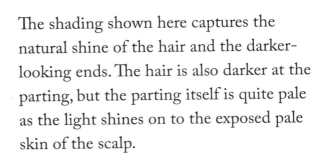

The shading shown here captures the natural shine of the hair and the darker-looking ends. The hair is also darker at the parting, but the parting itself is quite pale as the light shines on to the exposed pale skin of the scalp.

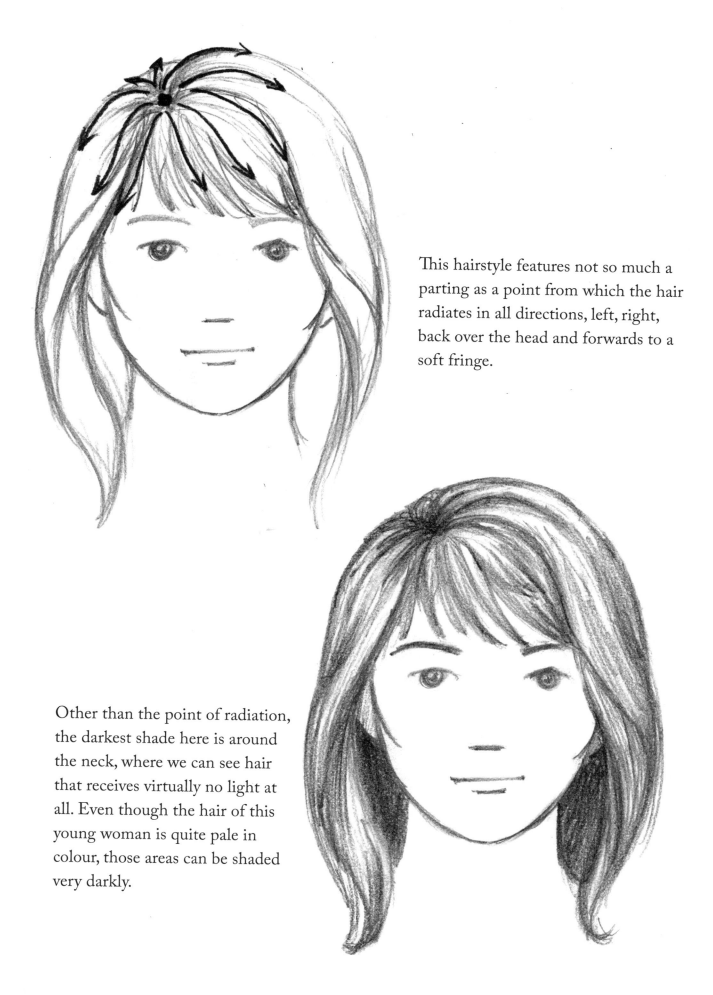

This hairstyle features not so much a parting as a point from which the hair radiates in all directions, left, right, back over the head and forwards to a soft fringe.

Other than the point of radiation, the darkest shade here is around the neck, where we can see hair that receives virtually no light at all. Even though the hair of this young woman is quite pale in colour, those areas can be shaded very darkly.

This much longer hairstyle parts in the middle and cascades down the sides of the face in gentle waves. Although it does not fall symmetrically, there is a degree of symmetry to the structure; the waves follow similar directional curves on either side, curving down and away from the face and spiralling back on themselves. It pays to take a little time to build the right kinds of structure into impressive hairstyles like this.

When shading this kind of hair, think of the waves as individual forms, each reflecting and shielding the light that falls upon it and casting shadow upon surrounding parts. Do try to keep your shading simple, though; even complicated hair should not be drawn with greater detail than the rest of the portrait you are working on.

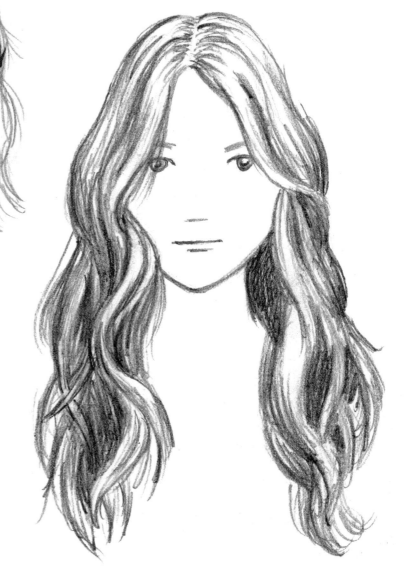

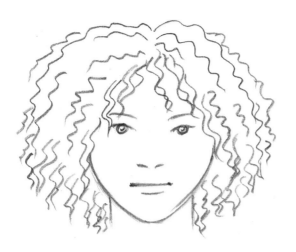

As we saw with the shorter curly hair on page 32, correctly assessing the mass and textural outline goes a long way towards depicting the mass of spiral curls that makes up this hairstyle. A few strands falling over the forehead are an important detail.

As in the earlier example, you can shade this image effectively without having to observe every curl. I have left some of the hair unfinished to demonstrate the kind of long spiral marks that I used, each emanating from the informal parting. A few speckles of white paper showing among the curls give a sense of shine and contrast with the solid dark around the neck and other shadow areas.

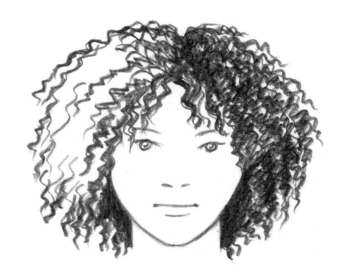

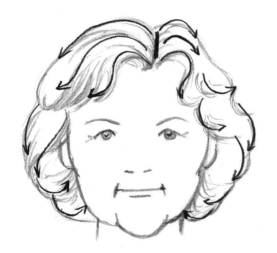

Older women's hairstyles are often a complex mass of curls that can defy analysis. The important features are the overall size and shape and how the hair frames the face. Draw the more obvious curls and waves, such as the parting and the way the hair falls on the forehead.

When adding shading, remember not to make the darks too pronounced and leave plenty of white paper. Follow the forms as best you can; as long as you employ the appropriate types of marks, some of the finer details can safely be guessed at.

The tilted head

When a subject's head is tilted up or down, or if you are viewing it from a higher or lower eye level, the proportions of the head alter from the straight-on views we have looked at so far. The new angles of view mean we see the features from above or below, changing the way in which they should be drawn. As before, some simple guidelines will help.

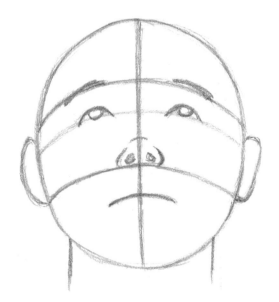

With the subject looking up, the straight horizontal guidelines of the template head must move up with the change of angle. Crucially, they must also curve to follow the rounded shape of the head. Thus the curving browline falls lower at the sides, which guides the much lower placement of the ears. From this angle, we see less of the forehead and more of the lower face and chin.

Here's a realistic drawing of a face with my construction lines. From this we can see the changes to the features. The upper curves of the eyes are exaggerated and the lower lids appear almost flat. There is a greater amount of space visible between eye and eyebrow. We see more of the underside of the nose and the upper lip, but less of the lower lip. From this angle, the chin becomes a dominant feature and we see underneath the jawline.

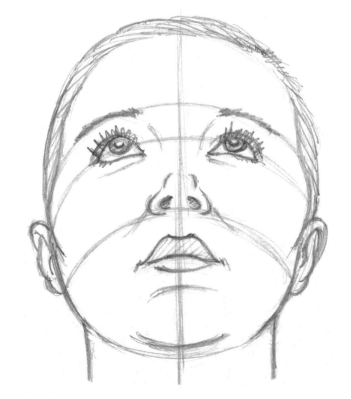

With the head tilted down, the opposite occurs. The horizontal guidelines curve upwards, away from the centre, and consequently the ears sit higher up on the sides of the head. More of the top of the head is visible, which you can see by the relatively low level of the hairline I have added to this diagram.

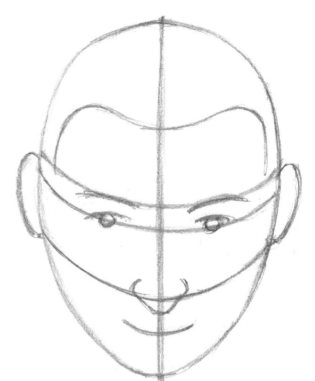

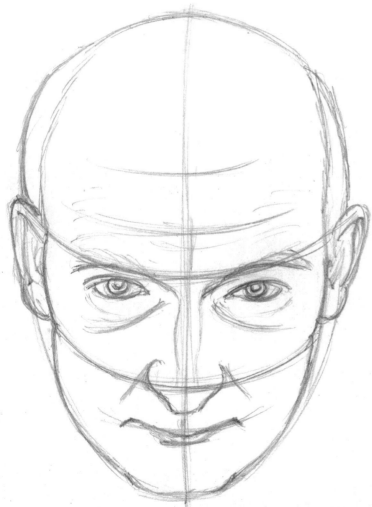

As we are effectively looking down on the face, the top of the head dominates the picture area, in this case making a feature of the subject's bald pate. The curve of the eyebrows is less pronounced here, as are the curves of the upper eyelids, but the lower lids can be seen clearly. There is little space visible between the eyes and eyebrows and sometimes the brows even overlap the eyes. The nose occupies a greater amount of space and is seen from above; the nostrils are hidden. Much or all of the upper lip is also hidden from view and the mouth curves upwards, even if the subject is not smiling. The shape of the jawline is very clear, and the neck is obscured by it.

Mark-making

Thus far we have looked at drawing the head in proportion, placing the features and observing their shapes. We have also seen how light and shade give a portrait three-dimensional form and bring sheen and texture to hair. To capture any of these elements requires that you make marks on the paper. The weight and quality of the marks can add a great deal to your interpretation of a person's face.

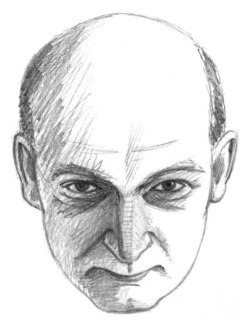

Step 1

Here's my bald friend from the previous page. In this version I have erased my guidelines and added some very basic shading. It works to some extent as a study of his likeness, but it lacks many elements of his character.

Step 2

I used the pencil in many different ways to produce a range of marks capturing more details that sum up the subject's careworn look. With a soft pencil held at a shallow angle, I honed the shading to follow the curve of his head and to deepen the shadows around his eyes. I used the tip of the pencil to draw all his wrinkles and character lines, pressing lightly for the shallow lines on the forehead and heavily for the more defined lines around the eyes. I then sharpened the pencil and carefully defined the eyes before lifting off the little glint in his eye with the corner of an eraser.

The sharp pencil point was also needed for the delicate hairs of the eyebrows, the textural marks of the hair and the suggestion of stubble that softens the jawline and adds to his characteristically haggard look.

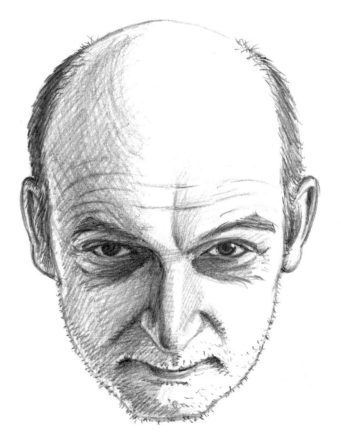

This line drawing focuses only on the lady's facial features and the most prominent of her wrinkles. The lines that develop with age do not usually fall symmetrically, as you can see here. Even in this simple line drawing I have taken care to draw the wrinkles with the appropriate degree of weight; very faint for shallow wrinkles and heavier for deeper lines, reserving the heaviest marks for the eyes, nose and mouth. The pale hair and eyebrows are also drawn with relatively light marks.

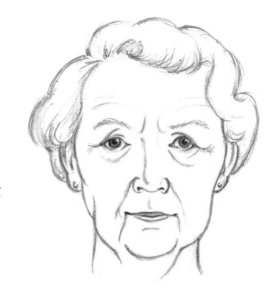

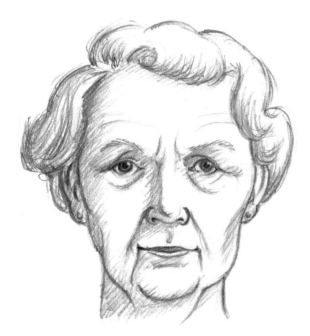

Shading an older person's face can easily follow a similarly light-touch approach. By keeping the shading fairly minimal, the wrinkles and character lines are not overemphasized and she retains a relatively fresh-faced look (your older family members will undoubtedly thank you for this treatment!)

The more detail you add and the heavier the shading, the older a face will look. If you choose to draw a person in such a way as to make a feature of their advanced age that's perfectly legitimate and can look dignified and imposing. But do take care not to overwork things and turn your drawing into a caricature of old age.

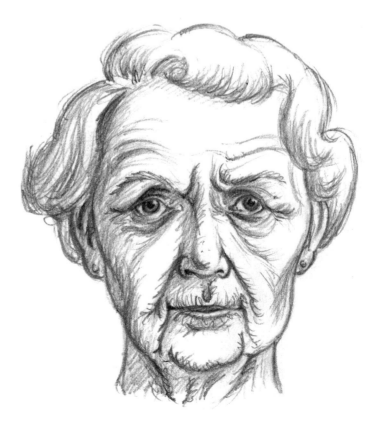

The concept of mark-making offers very much more than the portrayal of age. The kinds of marks used to create a portrait, together with your choice about which elements to bring out, can say a great deal about a subject's character, mood or the kind of image they project. This lady is feisty and unconventional and I sought to capture that attitude in my sketch. Of course, her marvellous expression conveys a great deal on its own, but it is supported here by direct, unfussy marks, concentrated around her penetrating glare and pronounced cheekbones. In drawing her wild hair, I ignored the play of light and shade and went instead for a vigorous, swirling mass of curls.

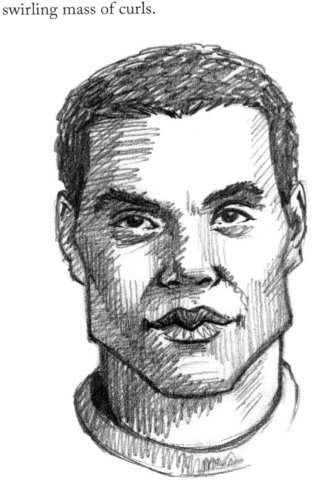

Although this handsome chap has quite rounded features generally, I took my cue from his sharp jawline and used similarly angular marks for the rest of his face, thus emphasizing his rugged side. For the shading, I went for a coarse hatching style, working in strict 45-degree changes of angle which give the rendering a workmanlike, almost industrial feel.

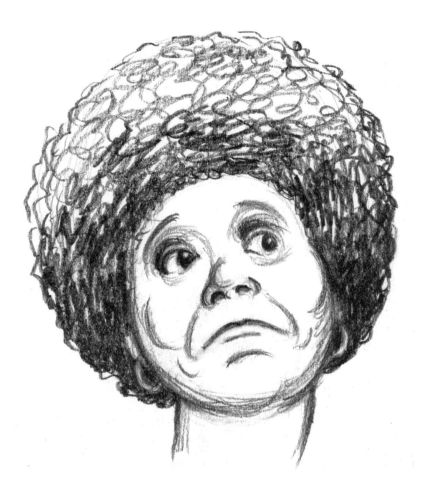

In contrast, this lady's features are so gentle and rounded that it seemed a natural choice to make all my marks soft and curvy, using a blunt pencil.

Here's the little boy from page 21, with shading and texture added. I was interested in the contrast between his unkempt hair, for which I used rough marks with the pencil's point, and his cherubic expression. The secret here is to keep the marks to a bare minimum; simple, clean outlines for the features and a touch of very soft shading around the edges, just enough to bring out the roundedness of the face without making it seem dirty or heavily shaded. I added a few freckles, but kept them very faint.

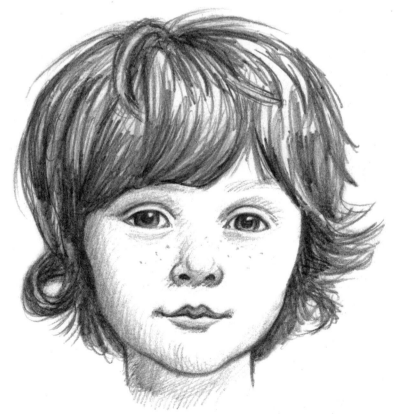

The Head in Three-quarter View

By now you should have a good grasp of how the head and face are constructed and how to go about drawing them. With this grounding we can now begin to embrace more sophisticated angles of view and look at the head turned slightly to the side – what artists call a three-quarter view.

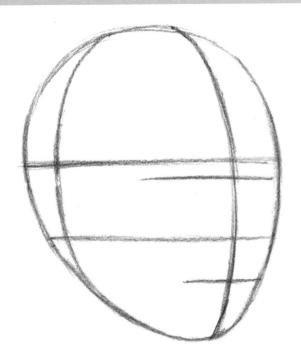

This diagram should be reasonably familiar by now, showing as it does a mixture of the construction lines we have already seen for profile and front views. From this angle, the egg shape is broader at the top to take in the side of the head, but not as broad as you would see when drawing a profile. The really important difference here is that the vertical centre line curves around the front to follow the shape of the head.

The construction lines guide the positioning of features. Their heights remain unchanged from previous examples, but their lateral placement must shift round. The eyes go in either side of the centre line, but not symmetrically; the one closest to us sits further back and the other eye appears closer to the nose. The lips are similarly broader on the near side and the nose protrudes beyond the centre line.

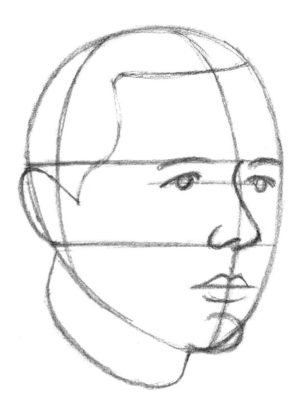

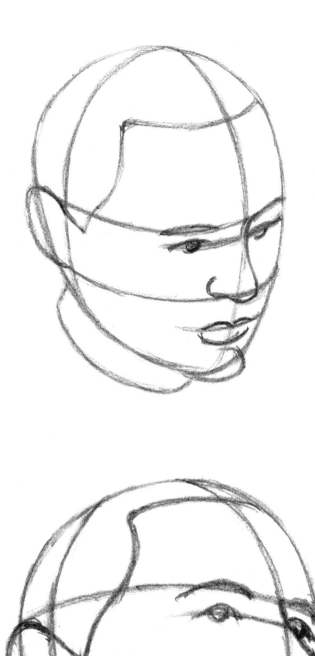

Here we see the head turned away and down. Naturally, both sets of guidelines now have to curve to wrap around the shape of the head. With the head turned down further, we can see that the curves of the lateral guidelines are more pronounced and yet more of the top of the head is visible.

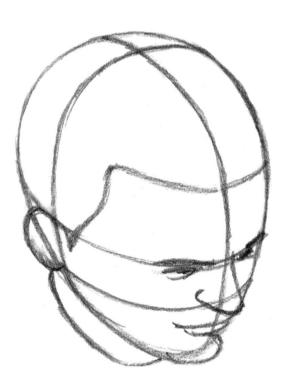

When looking up at a three-quarter view, the guidelines should curve in the opposite direction, as we saw when drawing the front view tilted up. Again, the steeper the angle of view, the more sharply the lines need to curve. A head seen from below will reveal the underside of the jaw, which may extend some way below the egg shape of the template head.

A portrait in three-quarter view

Getting to grips with diagrams and understanding the principles of the three-quarter view are all very well, but there are many complexities involved in making sense of the various planes, contours and undulations of the face from such viewpoints. Let us look at such a drawing in stages.

Step 1

I began by looking at the model for a minute or so to assess the shape and size of her head beneath the hair. Then I drew a plain oval, making sure to leave enough space on the page for the length of her hair. My eyeline was level with hers, so I marked a level eyeline halfway down her head. Then I added a vertical centre line curving around the front of the head and marked the rough levels of her nose and mouth.

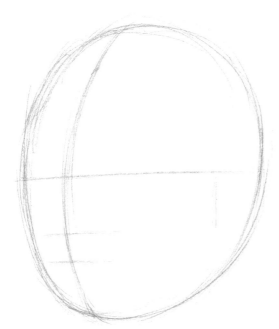

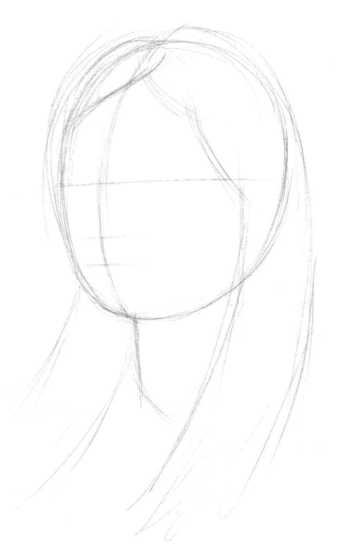

Step 2

I drafted the approximate mass and shape of her hair around her head, overlapping the forehead and neck.

Step 3

In this important stage I carefully mapped out the features, looking at their size, shape and position on the face. The centre line was very helpful in guiding their lateral placement.
I paid particular care in placing the eyes; being slightly sunken, eyes do not sit equidistant from the centre line at this angle of view.

Step 4

Happy with the basic features, I drew them in more detail and roughly shaded the irises to help me see how the likeness was shaping up. I drew the subtly undulating outline of her face, with the eye socket, cheek, chin and jawline. This is an essential element of a three-quarter view.

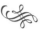

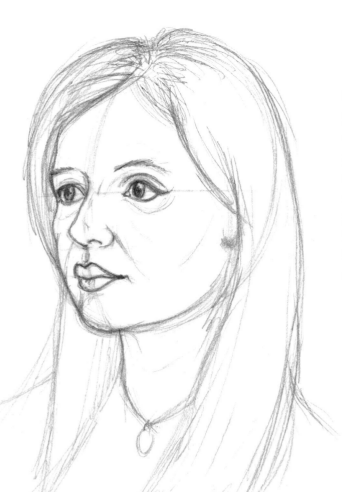

Step 5

I further refined the details of the face, adding some very faint marks to capture the delicate shifts of plane. These marks, under the eyes, on the bridge of the nose and so on, tend to make the model look older and may not always remain in the finished picture, but they help me to see the face as a solid form, which aids my interpretation of the shade on the face. I then turned my attention to the hair and drew some structural details into it.

Step 6

Before going any further, I carefully erased the scrappy marks and guidelines from around the established features, which gave me a clean drawing to develop with shading.

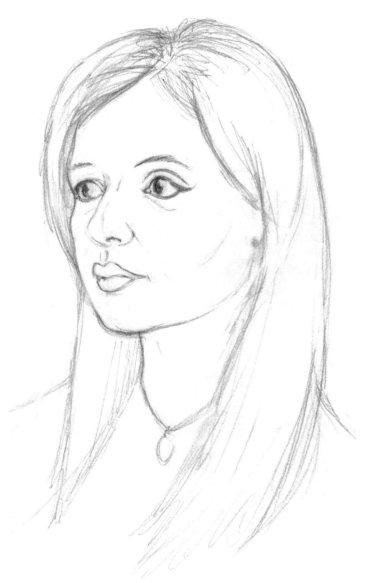

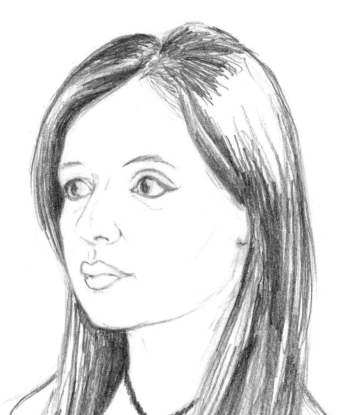

Step 7

This lady has particularly lustrous black hair, so it seemed sensible to make a strong feature of it in this portrait. I used a soft pencil to shade in the very darkest part and to begin developing the texture, always following the direction of the hair's flow with my pencil marks. The dark tone frames the face nicely and brings out the outline of the cheek and chin.

Step 8

I applied a second layer of tone to the hair, covering its surface in degrees of grey. For the shading on the face I chose a contour shading pattern, hatching in gentle strokes that wrap around the various planes of the face. Those above the eyeline, on the forehead, naturally curve down from the centre, while those on the neck, which I was looking down on slightly, curve the opposite way. Other shading lines follow the curves of the eye sockets, the striations of the lips and so on. For a suitably soft edge to the jawline, I used shading rather than a single firm line.

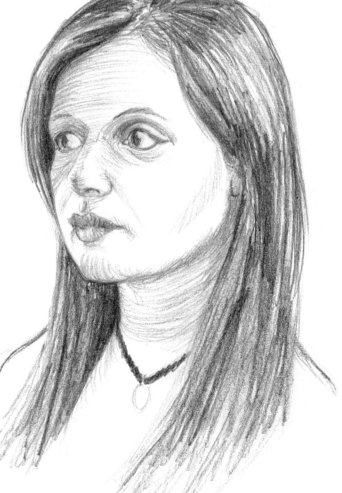

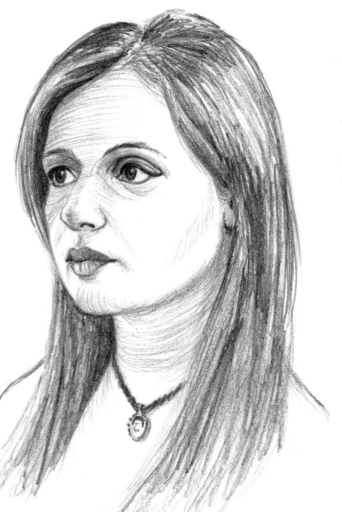

Step 9

I sharpened my soft pencil and worked in detail around the eyes, nose and mouth, carefully refining their shapes and shading and adding delicate contour hatching, particularly around the eyes. I took my time to draw the eyebrows, which are dark but very fine. It would be easy to make them too heavy.

Step 10

With the darkness of the eyes established, the hair was looking too pale, so I worked more dark into it. Although it may seem quite detailed, this is really only scribbling with purpose. Once the shape, structure and areas of shade are worked out, the hair can be shaded quite loosely as long as you always work in the direction of the hair's growth.

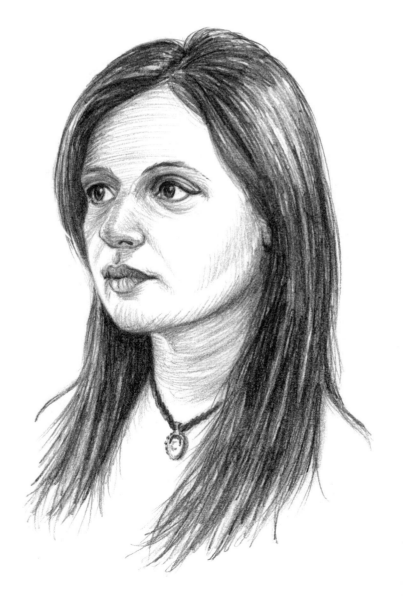

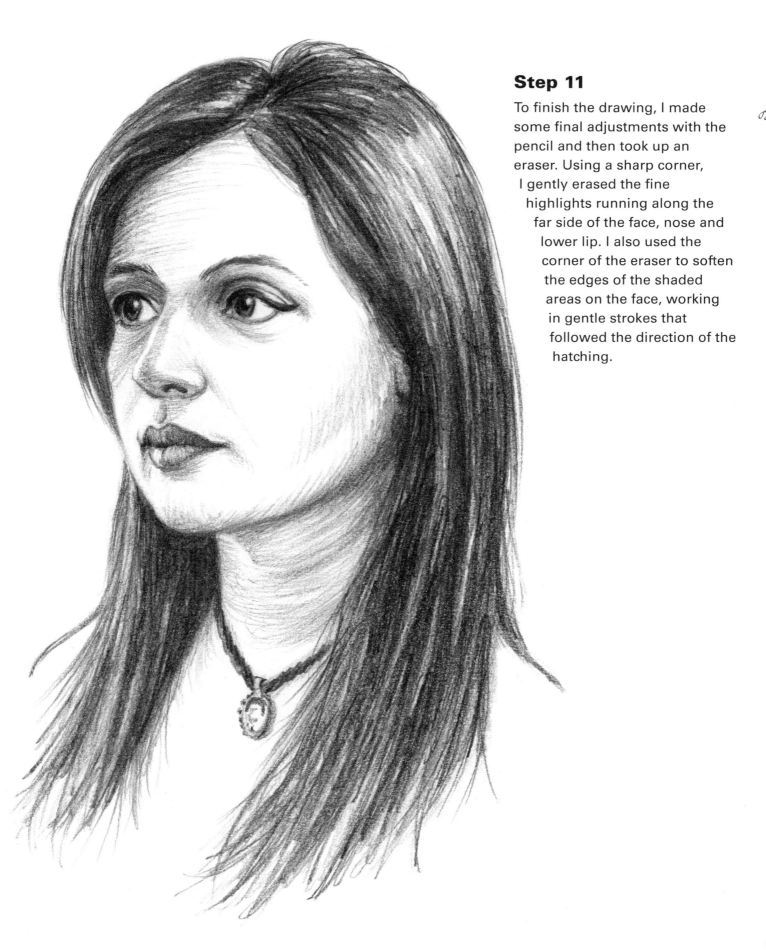

Step 11

To finish the drawing, I made some final adjustments with the pencil and then took up an eraser. Using a sharp corner, I gently erased the fine highlights running along the far side of the face, nose and lower lip. I also used the corner of the eraser to soften the edges of the shaded areas on the face, working in gentle strokes that followed the direction of the hatching.

CHAPTER FOUR

The Structures of the Face

As we come to draw portraits from more sophisticated perspectives, it is worth looking at the structures of the face in greater detail. Of course this doesn't mean you must always draw in detail, but a comprehensive understanding of the face will inform all your drawings, whatever their complexity.

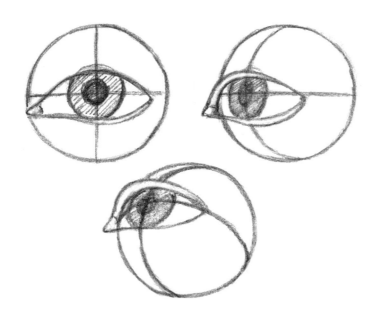

In most portraits, the eyes are a prime feature, containing much of a person's character and expression. For portraiture, it may be helpful to understand the underlying structure of the eyeball. Although the visible part of the eye is very small compared to the overall sphere, the spherical shape affects how the eye looks from every angle. Note that eyelids have a certain thickness, which is particularly visible from three-quarter views.

Generally, the iris is partially covered by the upper eyelid and rests just below the level of the lower eyelid. The white of the eye is not normally visible above and below the iris. Shading brings out the roundedness of the eyeball: the upper lid faces upwards and catches the light, whereas the lower lid curves under the eyeball and tends to be more shaded. Note also the shadow cast by the upper eyelid upon the white of the eye and the iris. A tiny white highlight gives a shine to the eyes.

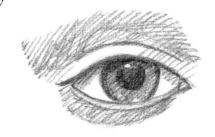
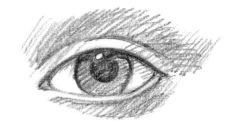

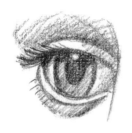

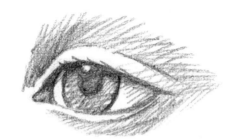

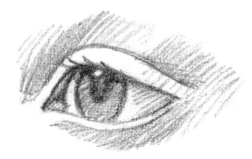

With the head turned progressively to the side, the shape of the eyeball becomes increasingly apparent. The iris becomes more elliptical and the curve of the eye more pronounced. The undersides of the upper eyelids become more visible, as do the tear ducts and eyelashes. The bridge of the nose increasingly obscures the eye on the far side.

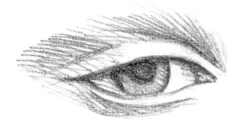

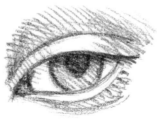

Seen from above and below, the shape of the eyelids changes greatly. A high viewpoint (above) reveals more of the upper lids and less of the lower ones, though the thickness of the latter is very clear. Conversely, viewed from below, the thickness of the upper lids is a strong feature even though much of the lids' upper surface is hidden from view.

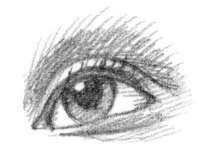

The nose, lips and ears

Unlike the eyes, the nose seems to be more of a problem for drawing when it is facing forwards. Beginners often resort to overelaborate shading to convey the nose's forward thrust. But as we have seen from our earlier line drawings, all it takes is some shrewdly observed details around the nostrils and the viewer is happy to supply the rest of the information in his mind's eye. Where shading is used, it needs only to describe the main planes that catch the shadow, along the side and underneath, with perhaps a cast shadow on the upper lip.

There are three things to remember about the perspective of lips: they curve in different directions; the upper lip is usually more in shade than the lower one; and they curve around the front of the face, meaning that one side will usually catch less light than the other. Most people's lips also curve away underneath so that a thin sliver of shadow is visible below the lower lip.

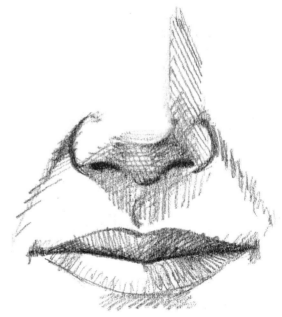

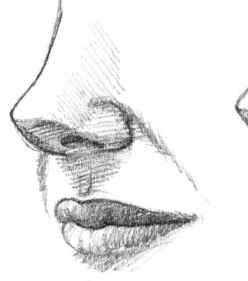

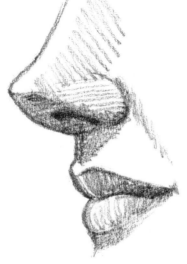

The curve of the lips is more apparent when the face is turned to the side. The shape of the nose also becomes more defined, making it a characteristic feature which requires close attention to its shape and size.

Higher and lower viewpoints reveal more or less of the upper and lower lips. The lateral curve is evident here in that the whole structures of the lips curve up or down with the altered viewpoint. Seen from above, the nose obscures the nostrils and may also cover part of the lips. Viewed from below the nostrils can be seen, but care should be taken not to overemphasize them lest they take on a snoutish look.

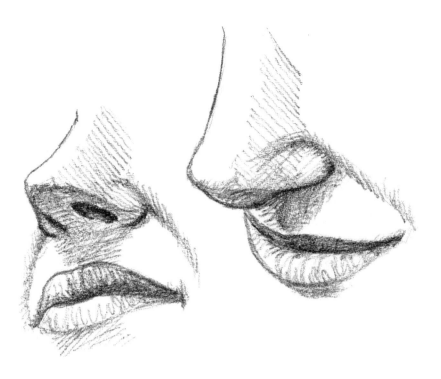

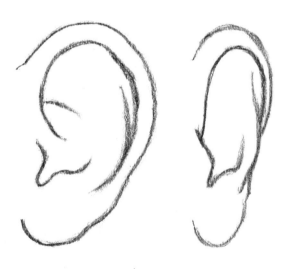

Ears are a funny shape. After many years working as an illustrator I still have to remind myself regularly of their structure. Part of the problem is that they have many 'soft edges' – gently curving parts that resist drawing with clear outlines. Here is an ear seen from the side and from the front. These line drawings show the clear, sharp edges that may be easily drawn. Note how the front view shows the inner structure protruding beyond the outer edge.

With some shading applied, the inner structures of the ear are now clearly visible. The angle of light falling on the ear affects its shading to some extent, but do not worry too much about it. As long as the ears are well placed and proportioned, they will do little to affect the success of a portrait drawing.

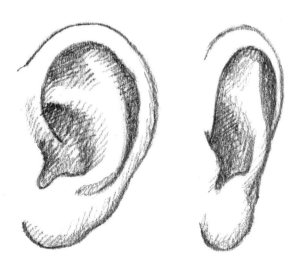

The planes of the face

Beyond the individual features, the face as a whole is composed of many curving and angular surfaces that all catch the light differently. Understanding the shifting planes of the face will greatly increase the ease with which you shade and bring solidity to your family portraits. Here are some exercises that will help you gain such understanding. They are also good fun to do and can result in some dramatic portraits.

For this exercise, I sat in front of a mirror and arranged a powerful lamp to shine on my face. My aim was to isolate the main areas of light and dark and to draw them with clear outlines. I decided to place definite boundary lines where the tones made smooth transitions. Effectively I was drawing a map of the light and shade on my face.

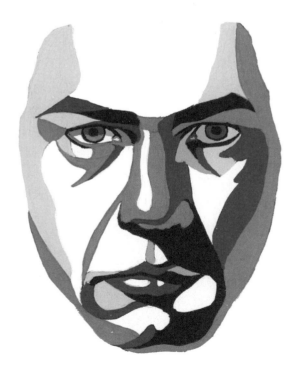

I then mixed four tones of poster paint, from pale grey to black, and filled in each part of the drawing with the appropriate shade, leaving the brightest areas white. As I added this tone, I continued to look carefully at my reflection and made some changes along the way. Forcing oneself to work within constraints often brings about an increase of understanding and can produce some interesting results. I like the bold, graphic look of this crude self-portrait.

Here I set about the drawing with a different aim, this time thinking about my face as a collection of flat surfaces, each reflecting the light differently rather like the facets of a jewel. Limiting myself to the same five tones as before forced me to simplify the drawing somewhat as I added the paint and continued to observe the fall of light on my face. The result is not much of a likeness, but it does have a very solid three-dimensional feel.

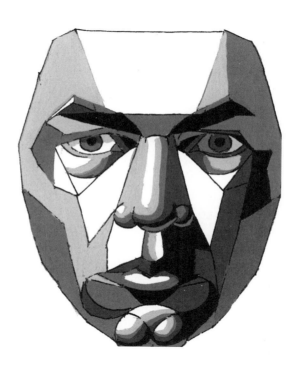

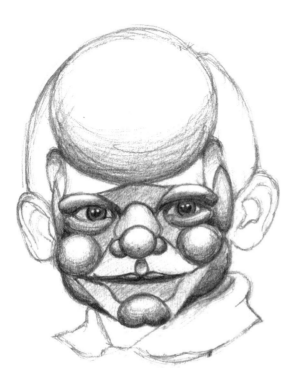

I was always fascinated by the roundedness of my son's features when he was young. In this experimental drawing, based on a photograph, I broke his face down into a collection of spheres and rounded forms and shaded each form individually. Although it's quite horrific as a portrait, it was a valuable exercise that informed the many drawings I did of him as he was growing up.

A structural portrait

As we have seen on the previous pages, looking at the face as a set of structures need be no mere distracting exercise. It can be a valid approach to making a portrait drawing, especially when a subject has a very angular face or clearly defined features. This is a way of thinking about the face as much as it is a drawing technique. Looking out for and setting down three-dimensional structural form as you draw makes for solid, convtincing faces that are full of character because every part of the face contributes strongly towards the likeness and expression.

For this portrait I worked from a photograph to spare the model the pain of holding his expression and to allow me to take my time interpreting the face. As you can see, the lighting in the photograph has come out rather even and flat, but a considered analysis of the face's structure enabled me to bring depth and form to the drawing.

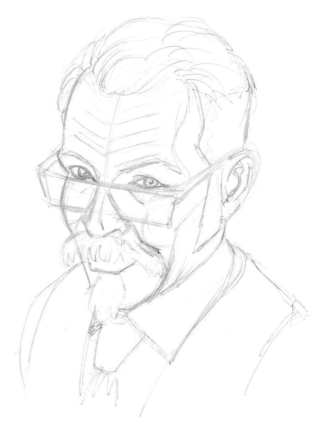

Step 1

As I drafted the head and features I was thinking of the various planes of which they are composed. Rather like the robotic self-portrait exercise on the previous page, I put in any structural marks I needed to enforce this interpretation in my own mind. I erased any unwanted guidelines to leave a fairly clean set of outlines.

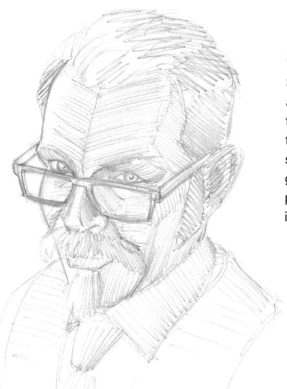

Step 2

Still working with an HB pencil, I hatched across the shaded areas, not so much to convey the levels of tone accurately as to establish the shifting planes and curved surfaces to guide the more studied shading that would follow. I also drew the shape of the glasses in more detail. It's worth spending time getting glasses right as they are an important element of a person's image. Glasses can easily look wonky or too heavy if you're not careful.

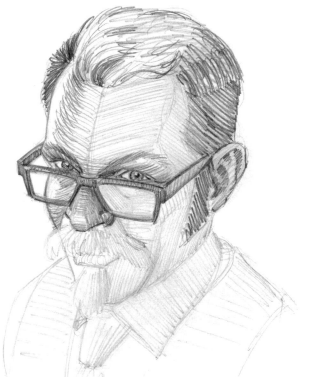

Step 3

With a softer pencil, a 4B, I set about firming up the main features. Starting with the eyes and glasses I worked systematically round the head, strengthening the deeper tones such as the hair, so that I could see the character developing.

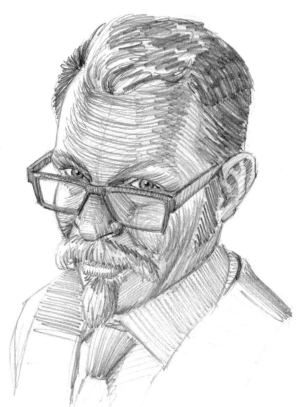

Step 4

Once I had finished my initial soft pencil work, I put in the skin tones, building up the layers of hatching to convey the fall of shade on the planes of the face. I worked some texture into the hair and moustache, treating them as structural forms in their own right and always following the direction of the hair growth.

Step 5

I refined the hatching to accentuate the light and shade and bring out its three-dimensionality. I added more shading and texture to the hair and darkened the glasses further. To bring out the smile more convincingly, I shaded the lower lip and invented deeper shading under the rounded forms of the cheeks. This was not visible in the flat lighting of the photograph, but was necessary to make the expression work in my drawing. There is more information about drawing smiles on pages 68–9.

Step 6

With the head pretty well finished, I added some detail to the collar, tie and waistcoat. Once those areas of tone were established I could see some weaknesses of tone on the head. So, to finish off, I strengthened the tones in the hair and used the pencil's blackest mark for the very dark parts of the glasses. This makes them seem to sit just that bit forward of the face and increases the illusion of solid form.

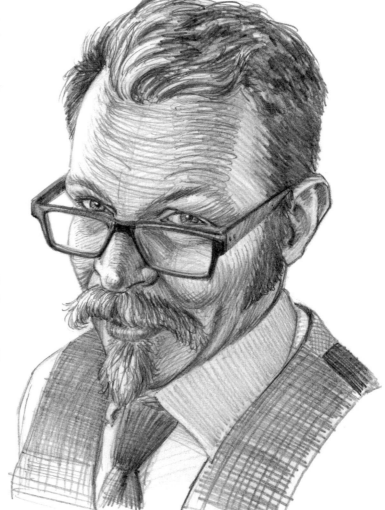

Lighting

When posing a model for a portrait, consider your options for the direction of light on the face. Be prepared to experiment, moving your light sources and model until you are satisfied. The way a face is lit can really contribute to the success of a portrait.

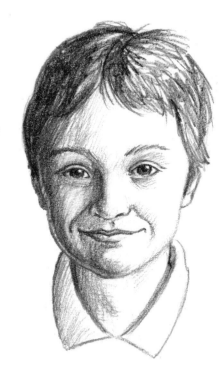

With the light coming from one side, the head looks rounded and solid and the planes of the face can be seen clearly, lending your drawing character and liveliness. Look out for reflected light, bouncing off the surroundings and bringing softer light into the darker parts, as can be seen here along the left cheek and nose. The light here is diffused daylight from a window that is not facing the sun.

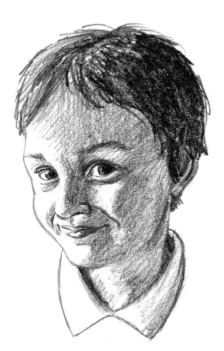

Diffused lighting from a side angle is a good standard lighting arrangement. From a three-quarter view this gives the choice of lighting the face from the far or near side. Lit from the far side (left) most of the face is in shadow, requiring more shading. This can work well for a slightly moody effect, or light can be bounced back on to the shaded parts of the face to give them more light and form.

When the light is shone on the leading surface of the face (right), it creates a much lighter feel and requires less shading. For many subjects this is a flattering arrangement and a useful scheme to employ when you are not aiming at any particular lighting effect.

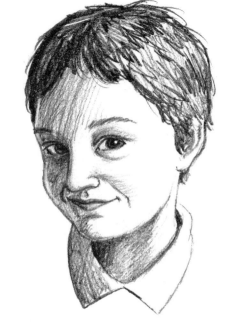

CHAPTER FIVE

Portrait Sketching

So far we have looked at drawing family portraits in quite an academic, studious way, dealing with proportions, angles of view, shading techniques and so on. Having gone through these essential lessons, we can now consider drawing faces with a sketchier approach. With a freer hand, the act of drawing becomes more pleasurable and the results are often all the livelier for it.

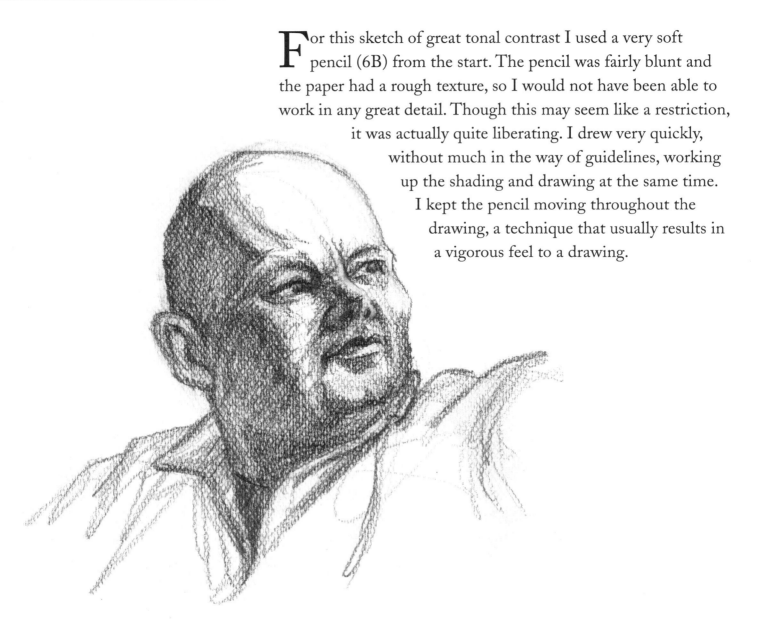

For this sketch of great tonal contrast I used a very soft pencil (6B) from the start. The pencil was fairly blunt and the paper had a rough texture, so I would not have been able to work in any great detail. Though this may seem like a restriction, it was actually quite liberating. I drew very quickly, without much in the way of guidelines, working up the shading and drawing at the same time. I kept the pencil moving throughout the drawing, a technique that usually results in a vigorous feel to a drawing.

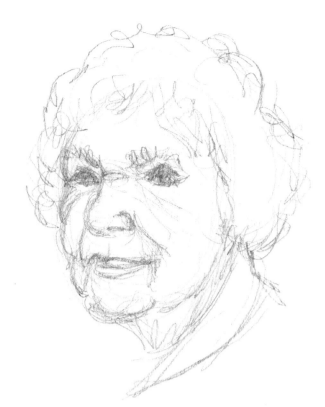

Step 1

Let's look at a similar drawing in stages. Here I used a 2B pencil, pressing quite lightly to feel my way around the forms and structures of the lady's face. I kept the pencil in contact with the paper the whole time, working round the features and character lines until I had arrived at a fairly complete under-drawing.

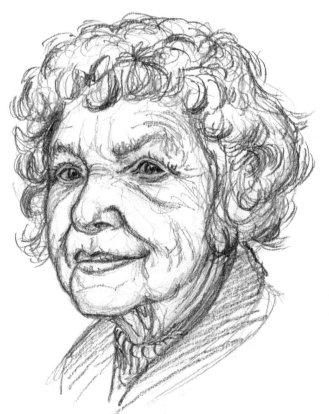

Step 2

As the drawing developed I started to press harder with the pencil, making more definite marks around the main features and letting the face gradually emerge from the mass of lines.

Step 3

Before continuing any further, I erased the eyelids to bring some form to the confusion of lines around the eyes, then I took a softer pencil (6B) and set about firming up the features and outlines. Although I was being quite selective in my marks at this stage, I maintained the same kind of freely flowing hand movements with which I had begun the drawing.

Step 1

In the act of sketching, we adopt a slightly different mindset from that of a more studied drawing. In essence, sketching is about setting down the information speedily and economically. Without time for careful observation and planning, we are liberated to some extent to draw as an instinctive response to a subject. I started this sketch with some very quick, vigorous marks.

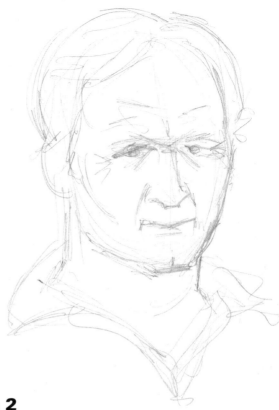

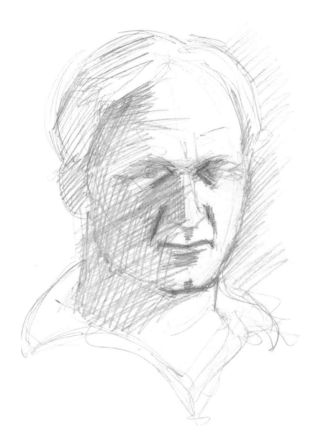

Step 2

With the model in strong light, casting deep shadows, it was sensible to shade the main shadow areas, which I did very roughly. For such quick, spontaneous sketching, try not to be hesitant; you can always erase and correct parts as the sketch develops.

Step 3

Pressing harder now, I drew the features with more careful observation, but still working quite speedily to maintain the drawing's haphazard feel. Drawing in the collar provides a kind of base to this strong head and neck.

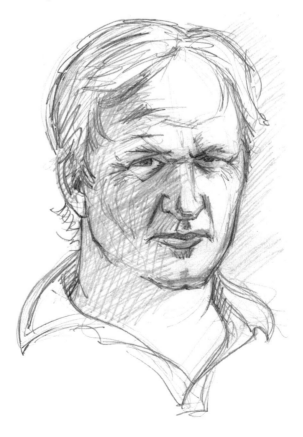

Step 4

Dark shading around the edges strengthened the contrasts with the face and brought out the bright lighting. It also helped me to read the tones overall and see where some extra shading was needed on the face. At this stage I was happy to leave the sketch with its rough and lively feel, which suits the subject. Although it could easily be refined further, something of the drawing's spirit might be lost if given too much polish.

Another quite different approach to sketching faces is to set down the features directly, with no guidelines and as few strokes of the pencil as possible. Although such quick sketches appear simple it's not an easy way to work and for every success you may make many failures. But limiting yourself to a few minutes for each sketch takes the pressure off and allows you to accept errors and move on quickly.

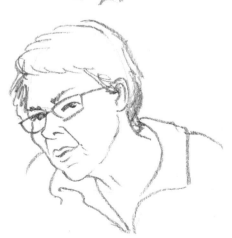

Here are a few quick sketches from my sketchbooks, all just a few centimetres in size and mostly done when the subjects were unaware that I was drawing them or were holding still for a spontaneous couple of minutes.

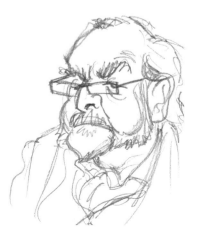

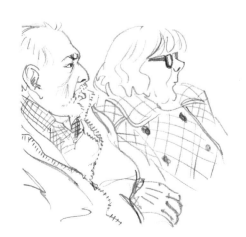

Practice

As you come to embrace the practice of sketching you may find it becomes quite addictive. There will not always be suitable people around for you to draw, but this need not deter you from exercising your sketching arm. Carved, sculpted and moulded depictions of faces can be found in all sorts of places, in a wild and wide range of styles. Here are a few sketches lifted from my sketchbooks, done in museums, churches and country houses.

However wacky they may be, sketching sculptural heads from three-dimensional objects is always good practice that will ultimately feed back into your family portraits.

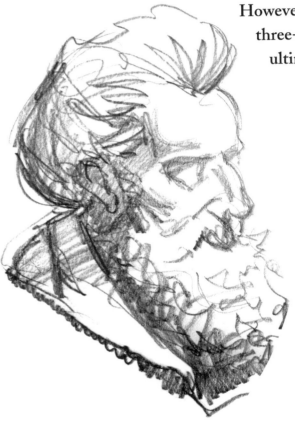

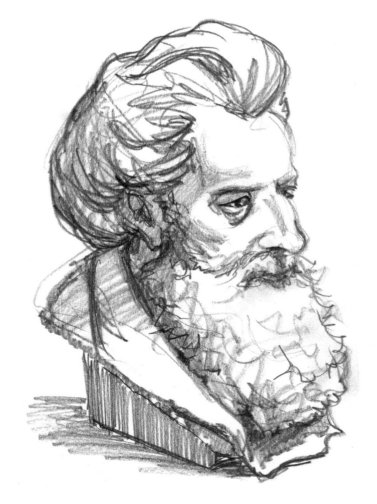

One of the great benefits of sketching from sculptures is that they do not move or lose patience. To draw this bust of the Victorian artist and designer William Morris, I used the flat side edge of a soft pencil to map out the main features and shade around the broad blocks of tone. I finished the sketch using the pencil point to set down the features more precisely.

Ancient cultures have left behind an impressive legacy of facial depictions. Sketching tribal masks is a rewarding pursuit, with much to teach us about alternative perceptions of the human face.

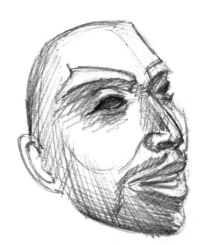

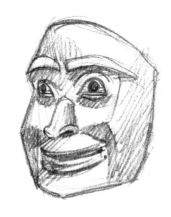

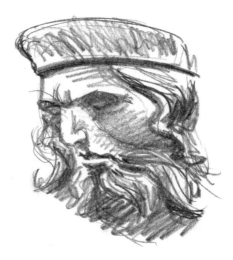

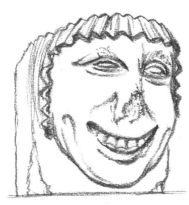

Two examples of medieval church carving in wood (far left) and stone (near left) are full of character and expression and well worth sketching for practice.

A 17th-century ship's figurehead provides a very different take on the face, steeped in the conventions of the age and unlike any modern portrait depiction.

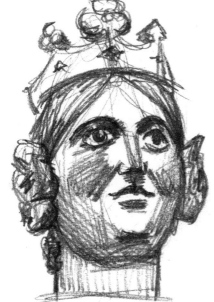

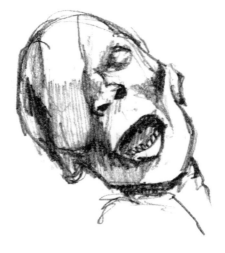

Some museums offer us the great privilege of sketching real human remains, such as this Egyptian mummy. Although the skin is dried taut across wasted muscle, it offers the chance to gain understanding of the hollows and ridges of the skull and how they affect the tissue of a living portrait subject.

Smiles

In family photograph albums, the subjects are usually smiling in virtually every shot. In real life we don't go around with grins on our faces, but people mostly expect portraits to look happy. If you form a smile on your own face as you draw, it provokes an empathetic response that really affects your drawings of smiles.

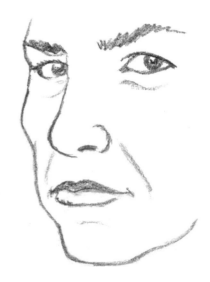

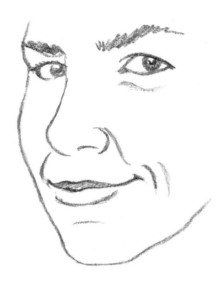

When the subject is showing no emotion, the facial muscles are relaxed. The outline of the cheek shows the prominence of the cheekbone and the fleshy part beneath, pulled down by gravity.

With the mouth widened and the corners slightly upturned, the mood is much more light-hearted. It's not just the mouth that has changed; the whole outline of the face is lifted and pulled taut by the cheek muscles. The eyes are exactly the same as in the previous sketch, yet they seem more cheerful.

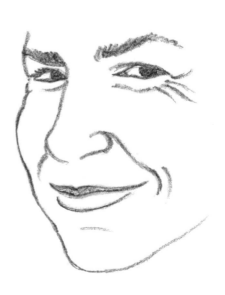

A really broad smile affects the eyes too. As they narrow, wrinkles appear around the edges, the cheek is lifted yet higher and the corners of the nose are pulled up. For a bigger smile, the teeth may be shown, which means that the lower lip and chin are lowered.

In profile, all of these changes can be seen very clearly. Note that the outer edge of the face is virtually the same in both these drawings.

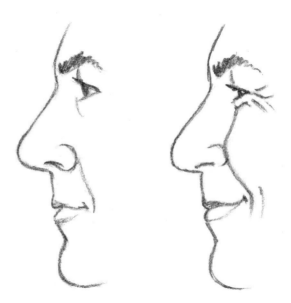

When drawing someone with a big grin, you have to show the teeth. Start by identifying a centre line and work outwards from there. A common mistake is to draw the teeth too firmly, with clear lines between, but this can make them look goofy and even gappy. Instead, leave the shape of the gum and the lower edges of the teeth to do the work.

The teeth of small children are usually quite straight and evenly sized. They occupy less space than adult teeth, so the dark areas in the corners of the mouth may be visible. Where there are gaps in the teeth, shade them in gentle grey rather than solid black.

As children's adult teeth start to come through there can be a range of different-sized teeth, some of them wonky. It is up to you to decide how much attention you want to draw to such teeth; usually they look quirky and endearing, but your model may be self-conscious about them.

Charcoal

In many ways, charcoal is quite a primitive drawing material. Really nothing more than burnt wood, it can be messy to work with and is unstable so it smudges very easily. But it's also surprisingly versatile, making marks that range from really dark to extremely subtle, and it can cover the paper very quickly. It is no surprise that charcoal is the medium favoured by many portrait artists, especially those who work in the street, for whom speed is always a factor.

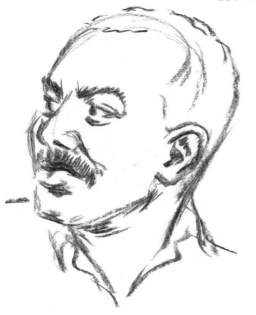

The broad, shapeless end of a charcoal stick may seem awkward and imprecise compared to a pencil. It's worth trying it out on scrap paper before you start any serious portrait, just to get used to the feel of the material. Remember that charcoal is quite forgiving; any lines that go astray can easily be erased or even just wiped away with a fingertip.

Step 1

I decided to be bold with this drawing to demonstrate the swiftness with which one may work in charcoal. I sketched the head in just a couple of minutes, with a similar approach to the one I used for the quick pencil sketches on page 65. At this stage all I needed to do was set down the features, without concern for light or shading.

Step 2

It took me another couple of minutes to do all the shading. I broke off a short length of charcoal, about 3 cm (1¼ in) long. I used this short length on its side to sweep across the skin tones and hair in broad strokes, laying down the tone in seconds. I used a fingertip to smudge and soften the transitions from white highlight to shaded areas and a clean fingertip to wipe off any errant marks. Then I used the pointy end of the charcoal to add a few last tweaks to the drawing.

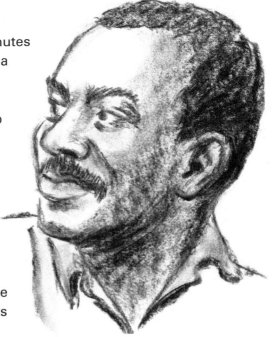

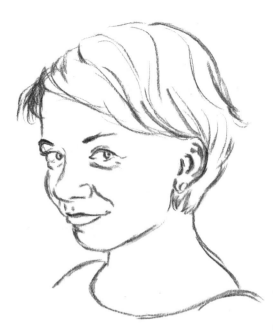

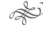

Step 1

Charcoal can also be used to produce gentler, more sensitive portraits. To depict a pretty young woman, I started with just as crude an outline drawing, although I did take care to draw the features accurately from the start. I marked some directional lines for the hair.

Step 2

Again using a short stick of charcoal on its side, I blocked in the main areas of tone in broad strokes. I shaded across the hair in similarly broad strokes, pressing harder for the darker parts and leaving some white paper for highlights.

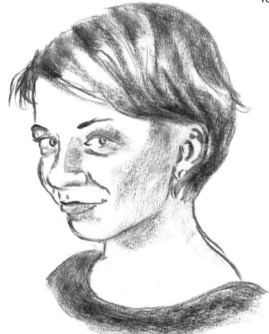

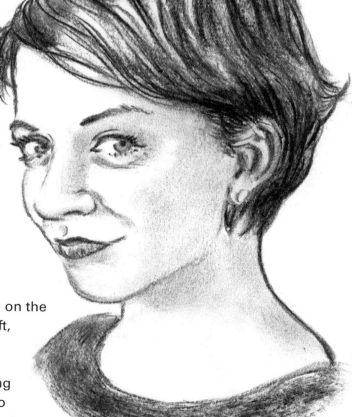

Step 3

With the tip of a clean finger, I smudged the shading on the face and worked it into the paper to create a very soft, almost uniform layer of shade. I then used the end of the charcoal to mark the detail of the hair in quite simple strokes, taking care not to smudge the existing shading. I sharpened my charcoal stick with a knife to give a fine point, and added the final delicate touches to the eyes and mouth.

A portrait in smudged charcoal

The seductive, rich, dark marks of charcoal lend this medium naturally to drawings of light and shade. Its smudginess means that drawings of great tonal contrast can be effortlessly softened for gentle effect. Smudging is a technique that can be embraced from the start of a drawing to quickly establish a sense of light and shade and to give the subject an atmospheric feel. For this demonstration, I sat the model in the soft, diffused light of a window.

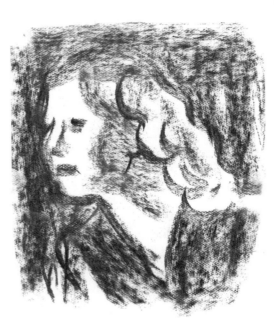

Step 1

I broke off a short length of charcoal and used it on its side to roughly set down the main blocks of shade on the head and background.

Step 2

With the tips of my fingers, I smudged the charcoal and pushed it around on the paper to smooth out the marks and soften the transitions of shade across the face and hair. I took care to keep the very brightest areas untouched and clean.

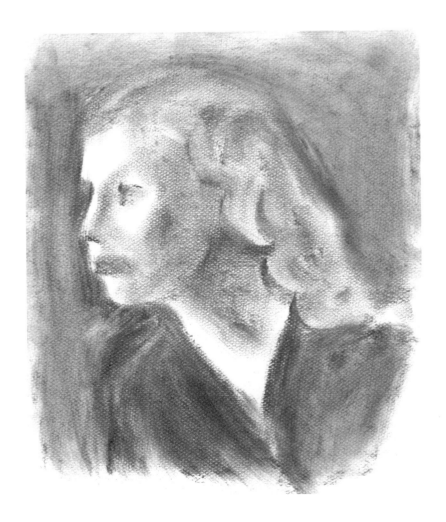

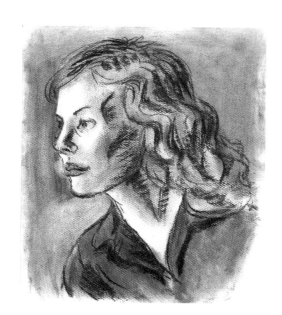

Step 3

Looking carefully at the model, I used the end of the charcoal to draw her features in more detail and establish some tone and texture in the hair.

Step 4

I used my fingertips again to soften and blend the new marks. With a clean corner of a kneadable putty rubber I carefully lifted off some areas of the face and hair, effectively drawing highlights with it. Such an eraser is very useful for working in charcoal because it does not leave flecks of debris on the paper, which would be tricky to sweep away without smudging your drawing.

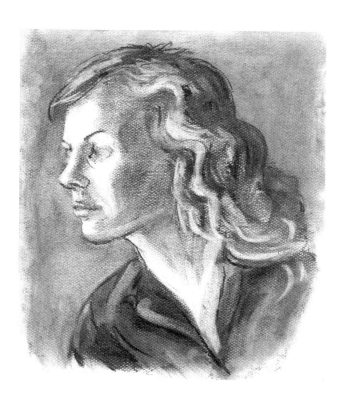

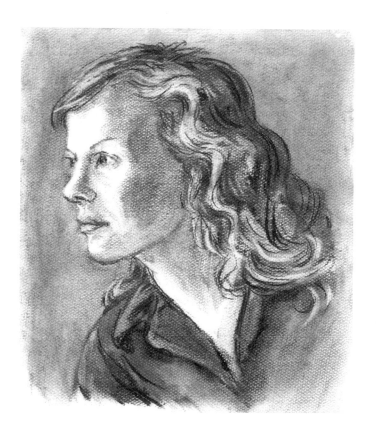

Step 5

I sharpened a stick of charcoal and used the fine tip to reassert some details to finish the drawing, keeping my hand well clear of smudging the surface. I then lightly sprayed the surface with artists' fixative spray to stabilize the charcoal and prevent it from further smudging.

Pen and ink

In many ways, drawing with a pen requires a completely different approach to charcoal. Most drawing pens are fine and precise and their ink is completely stable, so mistakes cannot easily be rectified. But this stability is a great blessing in that any amount of pencil under-drawing can be removed with broad strokes of an eraser once the ink has dried.

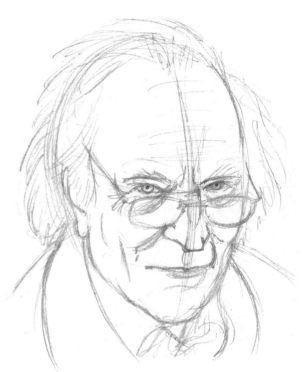

Step 1

I started this portrait with a strong pencil drawing. It is not very neat, but it does capture a good likeness even at this early stage. It is important that you are satisfied a drawing is on the right track before committing any outlines to ink.

Step 2

For this demonstration I used an artists' fine felt-tip drawing pen, which is inexpensive and produces a rich, consistent line of uniform thickness (in this case, 0.2 mm). Paying close attention to the model, I drew the outlines of the features, in some areas correcting or slightly altering my pencil drawing. I was careful not to make the outlines too heavy and black.

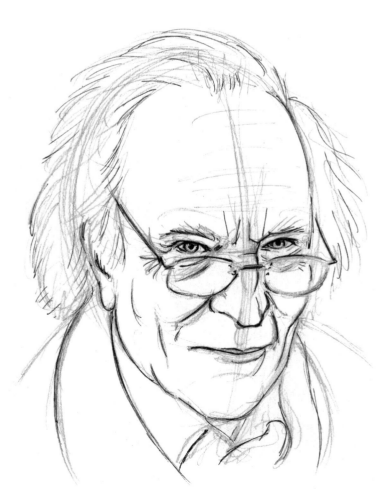

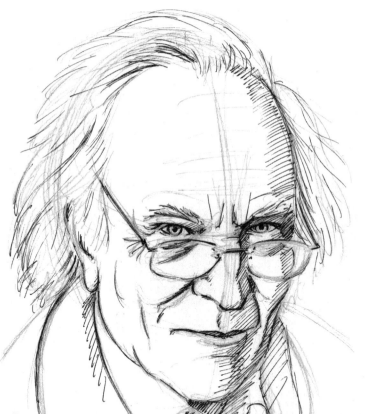

Step 3

I then started to hatch the broad areas of shade. Working quickly keeps a fresh feel to the pen work. I added some texture to the hair, again working quickly and using long, unbroken strokes to indicate the hair's fine, flyaway quality.

Step 4

Once the drawing is established it is easy to lose yourself in the pen work, with changes of hatching direction quickly building up subtle layers of shade. What matters more, though, is what you do not draw. As pen marks are so black, they should generally be used sparingly because they are not very good at describing faint shifts of tone. For this reason I have left much of the face and hair almost untouched. I was also careful to leave some highlights on the glasses and in other areas, such as the lower lip where it catches the light and would look wrong if outlined in black. After waiting for a couple of minutes to make sure the ink was completely dry, I erased all the pencil marks in one go.

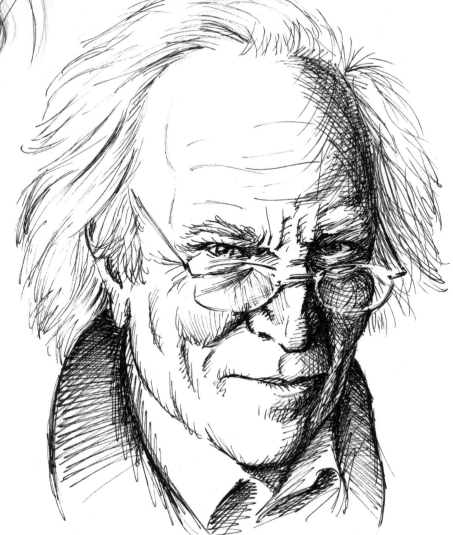

A portrait in steel-nibbed drawing pen

The traditional artists' drawing pen is the old-fashioned type which you dip into a bottle of ink. Pens such as these are not as easy and convenient to use as modern pens, but their flexible nibs make for more elegant marks of varied weight depending on the pressure applied. They can be messy and difficult to master, but are worth the struggle.

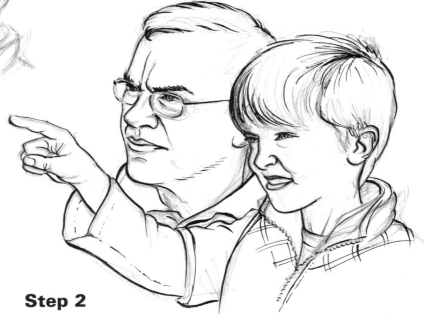

Step 1

It's a good idea to start with a fairly detailed drawing before using any ink. You need not draft every hair and wrinkle, but you'll need enough information to make a confident stab at the inking.

Step 2

As in the previous demonstration, it's best to begin quite tentatively, mapping out the main outlines with close reference to your model or source photograph. Try to make intelligent use of the nib's flexibility, pressing harder for firm outlines and with less pressure for more delicate details. Work in smooth, confident strokes of the pen, always pulling the nib in a downwards fashion. If you try to push the nib upwards, it will catch on the paper and splatter. It is worth practising your strokes on scrap paper so that you get used to handling the pen.

Step 3

Before going on to do any shading, you may like to erase your pencil marks. It is essential, however, that the ink is completely dry before you do so. It may take an hour or more for the heavier lines to dry thoroughly, although you can speed things up by blotting with tissue paper and warming the paper with a hairdryer.

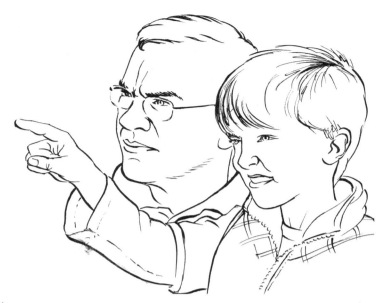

Step 4

With a dip pen, it is usually best to keep the hatching simple and minimal. I worked over the shade areas in clean, uniform strokes, often following the contours of the faces and clothing. I then set my work aside to let the ink dry.

Step 5

Before working any further I had a good long look at my drawing to see which parts really needed more shade and depth. If parts of the drawing look good already, I am always loath to add more complexity for the sake of it. As well as strengthening some parts of the hatched areas, I went over some of the outlines to give them extra weight and clarity.

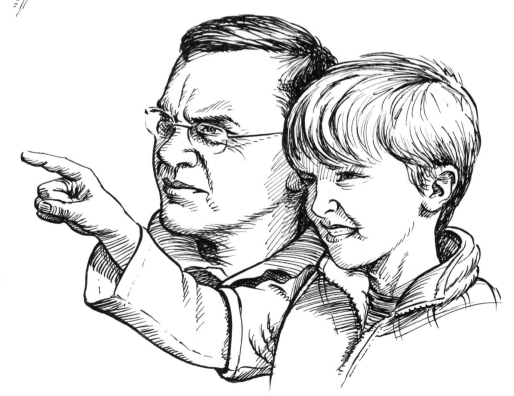

Using different pens

Although the previous pages describe the need for careful under-drawing for a portrait in ink, as you become more comfortable with this medium you may find it useful for less studied drawings and sketches. There are many different types of pen available, all of which have their own mark and particular strengths and weaknesses as drawing and sketching tools.

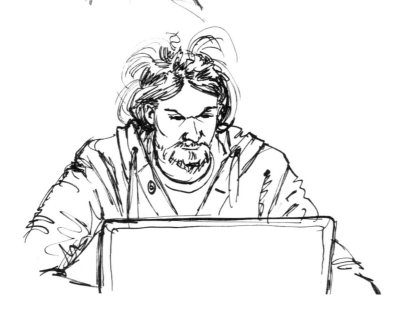

This spontaneous sketch was done with what I had to hand – an ordinary ballpoint pen. This unlikely drawing tool is capable of making delicate marks that are quite forgiving and lend themselves rather well to sketching.

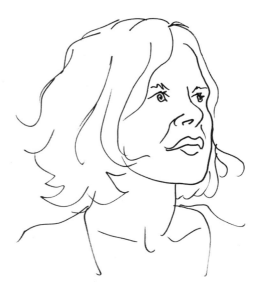

Where your subject is rather scruffy, there is little pressure to get things accurate when sketching directly in ink. Here I used a drawing pen with a chisel-shaped tip, which gives variety to the line and makes it less neat and controlled.

For this portrait of my wife, I used one of my daughter's felt-tip pens, which produces quite a crude, simple line. I made the drawing similarly simple, using the bare minimum of lines. It would be perfectly legitimate to draft the head in pencil before embarking on such a challenge.

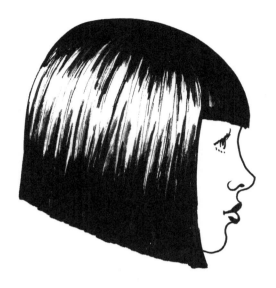

Cruder still is the thick, dense line made by a chisel-tipped marker pen (left), but every material has its strengths. By grazing the pen swiftly across the paper it leaves a mark that is well suited to capturing the lustrous sheen of straight hair.

Brush pens are usually felt-tip pens with a very pliable brush-shaped tip which produces a brush-like line of varied weight, without the inconvenience of traditional brush and ink methods. Such pens are great sketching tools, allowing for both delicate mark-making and broad shading.

Some brush pens have an actual brush tip fed by an ink cartridge. Ink flow is usually slow with such pens, making for a fractured quality of line. However, every type of mark can be harnessed to some effect and here I married a slow-flowing brush pen with some rough handmade paper to bring an extra textural element to this simple outline drawing.

Graphic impact

The stark black and white contrasts achievable when drawing with ink on white paper open up further possibilities for controlled, designed portrait imagery of a bold, graphic nature. The main principle here is to aim for simplicity, wherever possible. The less clutter in such a design, the stronger its graphic impact.

With a clear aim in mind, it's possible to bring a bold graphic feel to even a very quick sketch. In this example I spent more time considering what to leave out than drawing the brush-pen lines.

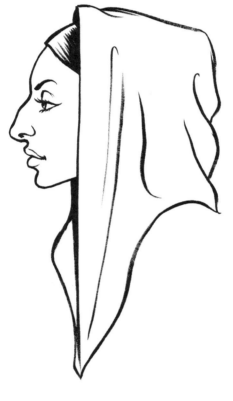

A yet more stripped-down approach is well suited to showing off the beautiful profile of this Egyptian woman and makes a strong design feature of her headscarf. I drew this carefully in pencil, then went over the outlines with a brush pen and erased all trace of the pencil work.

In the 19th century there was a vogue for silhouette portraits, typically cut out of black paper. Here I have updated the idea for a modern couple. I drew the outlines in pencil and filled them in with black ink using a fine brush. To do this in cut paper, use a pale-coloured pencil for the drawing then, once you have carefully cut it out, simply turn the paper over to reveal a perfectly clean black surface.

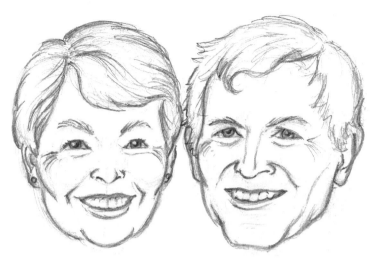

Step 1

This is a double portrait I designed for a fiftieth wedding anniversary. I found some snapshots of the couple and brought the best two together as the basis for this design. The initial drafting is really quite rough, requiring a lot of reworking to capture both the likenesses and expressions with a minimum of detail.

Step 2

With a fine, round watercolour brush and a pot of black ink, I carefully inked over the pencil drawing, aiming for grace with every line drawn. Think of each mark individually and lay them down with a single unbroken stroke of the brush. There is a balance to be achieved between bold mark-making and holding back from making unnecessary marks. When you have finished, always clean your brush immediately in water, reshape the point and stand it upside down to dry.

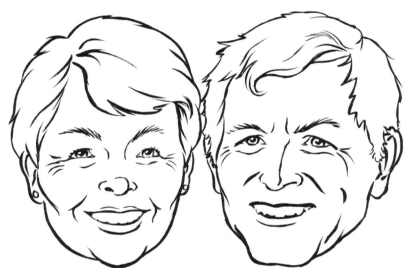

Step 3

With all pencil marks erased, I could see where the drawing needed a few aesthetic touches. I used the same fine brush and white ink to clean up around some odd slips of the brush and to make the lines and features neat and unfussy. Once the white ink was dry, I reverted to black ink and painted a strong outline around the two heads to make them stand out as a clear, unified design.

A portrait in diluted ink

When using a separate brush, you can dilute your ink to gentle tints and achieve more subtle and seductive line and tone effects. The principles remain the same as for a pen, but there is the added complication of deciding on and mixing the appropriate strength of ink for each element of a portrait. Watercolour paint can be used in the same way, or ink and watercolour can be combined.

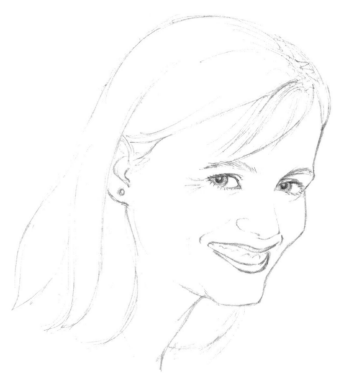

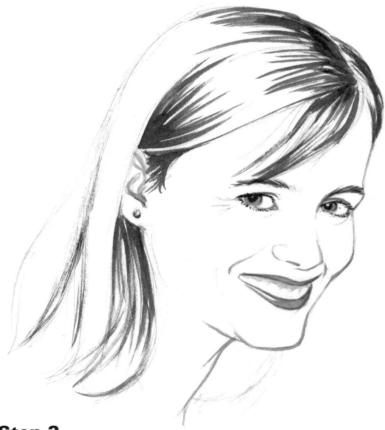

Step 1

Knowing that I would be getting the paper quite wet, I started with some heavyweight paper because thin paper buckles and distorts when wetted. I wanted to keep this portrait clean and fresh, so I did faint and minimal initial pencil work and erased all unsightly marks before embarking on the brushwork.

Step 2

With a fine brush, I drew the darker parts of the eyes in pure black ink. For the other dark parts, which are not so black, I mixed the remaining ink on the brush with a little water in an old saucer and painted the eyebrows and the more shaded parts of the hair. I then diluted the ink further for the lips, outline of the face and remaining features.

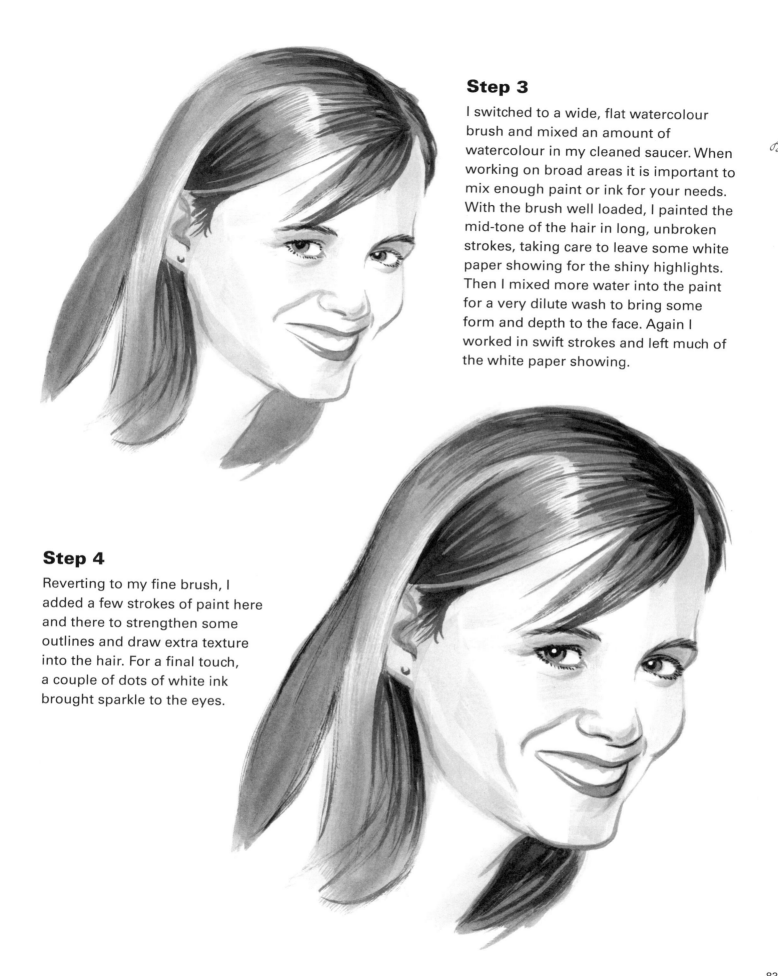

Step 3

I switched to a wide, flat watercolour brush and mixed an amount of watercolour in my cleaned saucer. When working on broad areas it is important to mix enough paint or ink for your needs. With the brush well loaded, I painted the mid-tone of the hair in long, unbroken strokes, taking care to leave some white paper showing for the shiny highlights. Then I mixed more water into the paint for a very dilute wash to bring some form and depth to the face. Again I worked in swift strokes and left much of the white paper showing.

Step 4

Reverting to my fine brush, I added a few strokes of paint here and there to strengthen some outlines and draw extra texture into the hair. For a final touch, a couple of dots of white ink brought sparkle to the eyes.

A portrait in watersoluble pencil

Watercolour or diluted ink is an effective medium, but it's not very easy to master. However, similar effects can be achieved more easily with watersoluble pencils, crayons and the like.

Step 1

I used a soft watersoluble pencil (6B), which can be bought at an art shop for little more than the price of a standard pencil, and a sheet of textured watercolour paper. I drew the model just as I would for a normal pencil sketch and shaded the main areas of shadow with rough hatching.

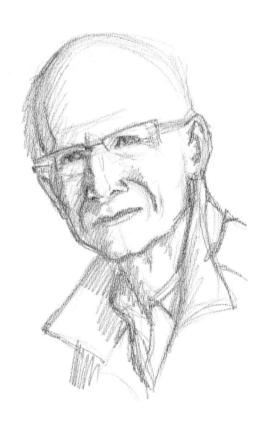

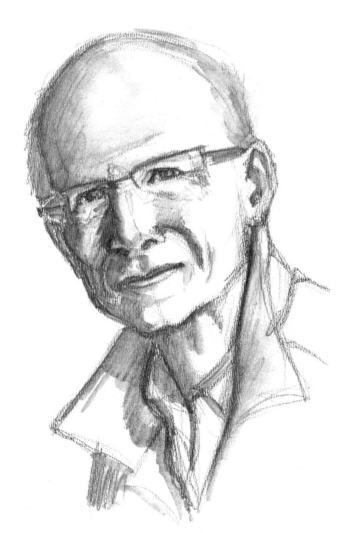

Step 2

I dipped a medium-size round watercolour brush into some clean water and simply painted it over selected parts of the drawing. The water dissolves the pencil, softening the marks and allowing you to spread the pigment around in a painterly fashion. Although this is quick and easy to do, you must work with a degree of sensitivity to the subject, making sure you do not allow it to blur so much that you lose your original drawing.

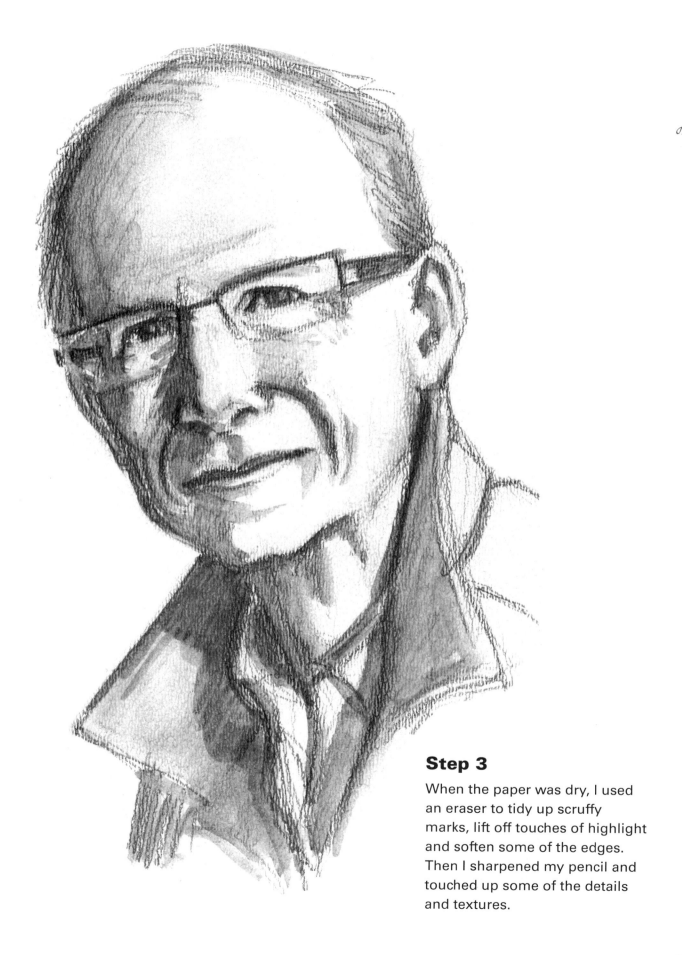

Step 3

When the paper was dry, I used an eraser to tidy up scruffy marks, lift off touches of highlight and soften some of the edges. Then I sharpened my pencil and touched up some of the details and textures.

Toned paper

It has long been a convention of portrait drawing to work on grey or coloured paper, known as a 'toned ground'. The reason for this is that a mid-tone is established from the start, requiring less shading, and, more importantly, highlights can be added in a white or pale material to give the drawing sheen or luminosity. For this demonstration I seated the model in sunshine to show the use of bright highlights and gentler reflected highlights.

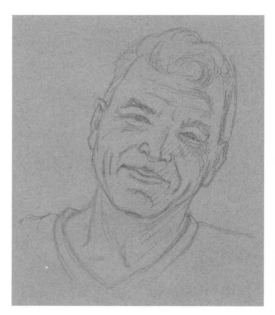
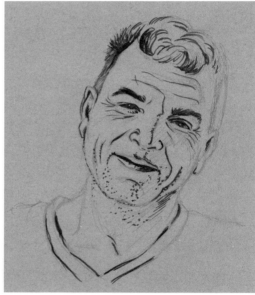

Steps 1 and 2

I drew the face in pencil, including all the crags and wrinkles made so clearly visible by the bold lighting. I then used a fine brush and black ink to draw the darker details.

Step 3

Switching to a heavier brush, again loaded with black ink, I squinted at the subject so that I could clearly see the areas of deep shadow, then painted them in with broad slabs of solid black. As the ink ran dry on the brush, I painted the slightly softer parts, the shading of the neck and the transitions from black to grey. Once the ink was dry, I erased most of the pencil marks, leaving only the guidelines needed for the highlights to come.

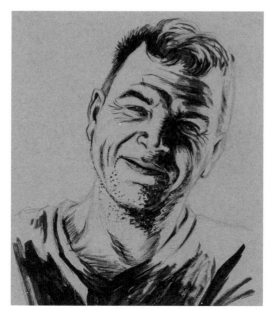

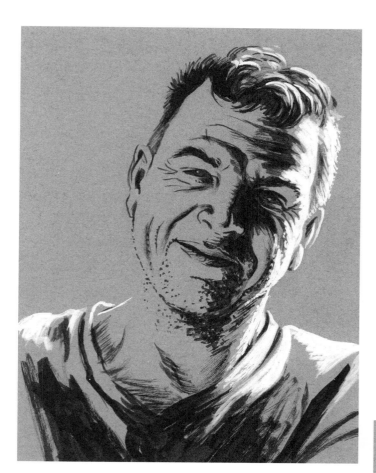

Step 4

Having thoroughly cleaned my medium watercolour brush, I used white ink to paint the harsh highlights down the right-hand side of the head and across the top of the shoulders. I could very well have left the drawing at this stage, but there were some definite highlights reflected back on to the left-hand side of the face which would bring form to that side of the drawing.

Step 5

For the subtler highlights, I diluted some white ink and dabbed the brush semi-dry on some tissue paper. Thus I could swiftly stroke on some touches of reflected light, confident that they would not conflict with the bold brightness of the strong side light. When working on a toned ground, it usually pays to keep such highlights quite minimal and to leave a good amount of toned paper untouched.

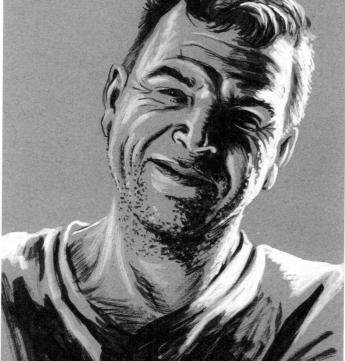

Composition and framing

When artists talk of framing, they do not necessarily mean placing a portrait within a physical frame. The word also refers to the decisions taken on positioning the notional boundaries around a picture. Thus we get into the subject of composition – the placement of the elements within a picture area. This is an important subject that can contribute greatly to the success of a portrait and the mood it conveys.

A small piece of cardboard with a rectangular aperture is a useful tool. You can view your subjects through it to help envisage them within a frame for composing a portrait. You can also look at a finished drawing through it and see how different framing may suit the work.

It may seem obvious to place the head in the centre, but there are some important things to consider even with such a simple composition as the one here. For a start, the head is not in the centre – it is significantly higher in the frame. There should always be more space below the head than above, otherwise it will appear to have dropped in its framing. This head is also slightly to the right of centre, but the model's left eye is positioned centrally, an age-old device that makes the whole head seem to sit comfortably within the frame. Furthermore, the eyeline sits about a third of the way down the picture. The 'rule of thirds' is very commonly employed, placing focal points at satisfying divisions one-third into the picture area.

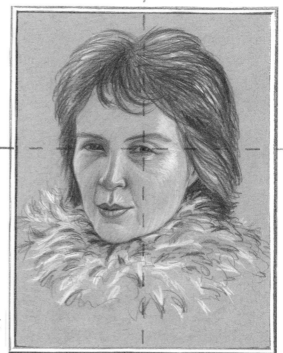

A portrait may also occupy a horizontal 'landscape' format. In the image on the right, the eye is about a third of the way into the picture both

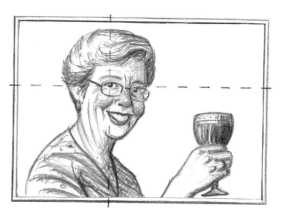

horizontally and vertically. The figure leans comfortably into the picture and the empty space is elegantly filled with a secondary feature – a glass of wine.

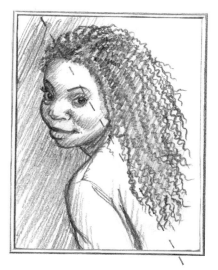

A head or figure angled across a picture breaks up the space diagonally. This lends a portrait dynamic thrust and makes the subject appear lively and graceful.

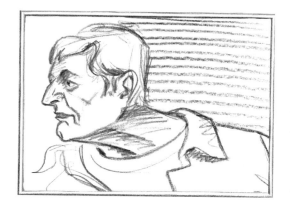

Leaning towards the edge of the frame gives the idea of a character who can't be contained. The horizontal background shading suggests forward motion.

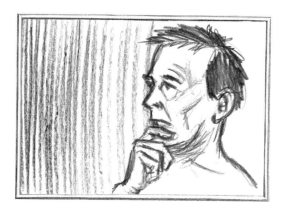

The head here is leaning back from the space to its left, conveying a feeling of thoughtfulness and hesitancy that would not be achieved with his expression alone. Vertical shading helps to give a static impression.

An intense feeling can be generated by showing just part of the face without any surrounding space. You may plan this from the start, or you may decide to crop a portrait in this way after you have drawn it.

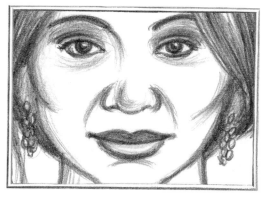

CHAPTER SIX

Full-length Portraits

A typical portrait may comprise a person's head and shoulders, but of course you can include more or all of the body in a portrait. As with drawing portrait heads, it is useful to gain an understanding of the proportions involved when drawing the full body.

The standard measure of figure proportions is head lengths. However tall a person may be, their body can be broken down into generally similar units, according to their age.

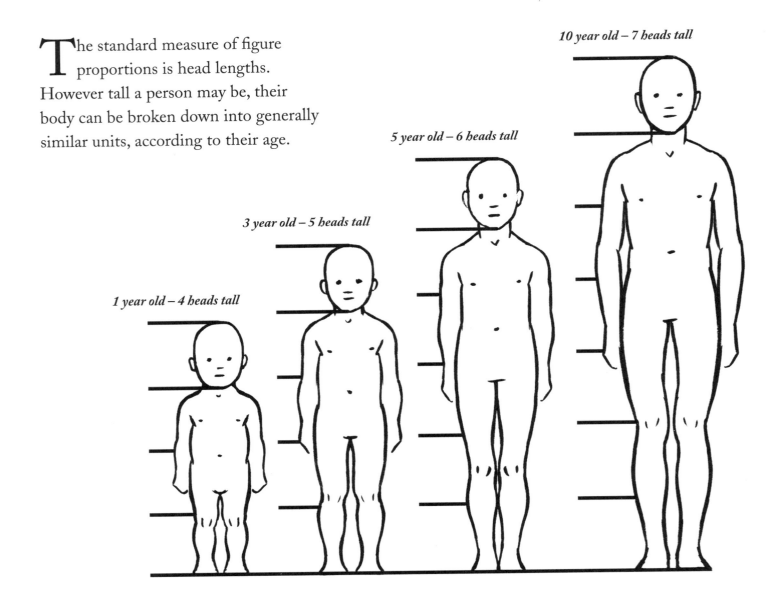

10 year old – 7 heads tall

5 year old – 6 heads tall

3 year old – 5 heads tall

1 year old – 4 heads tall

The proportions of the body change dramatically through early childhood, as the chart below demonstrates. At about a year old, the head occupies a large proportion of a baby's overall height, which is about four head lengths tall. By the age of three, the limbs and trunk will have grown longer relative to the head, making the body about five head lengths tall. At around five years of age, the child will be six heads in height. The rate of relative growth slows down thereafter and it will be another five years before a height of seven head lengths is reached. These proportions are equally true of boys and girls. Although adults vary greatly in their body types, the great majority conform to a standard height of around seven-and-a-half head lengths, whether male or female. This general rule of thumb is unchanged by the stature of an individual; a shorter person will usually have a shorter head and vice versa.

The figures represented here are both healthy specimens in the prime of life. As they grow older, they may develop broader shoulders, bellies and hips, their posture may stoop, but their general proportions of height will remain relatively unchanged.

Before we move on to drawing, it's worth acquainting yourself with some of the other proportions of the body. Note, for example, that legs are around four heads long and arms are about three heads, including the hands. The upper body is relatively short, at two heads from shoulder to navel. The width across the shoulders is about two head lengths.

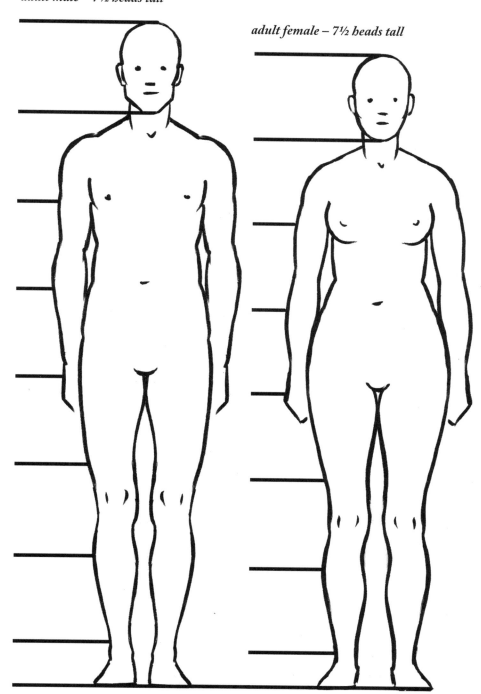

adult male – 7½ heads tall

adult female – 7½ heads tall

This sketch is a perfectly serviceable, well-proportioned representation of a standing man. It is also very boring.

It doesn't take much of a change to liven up a pose. Here the stiff angles and symmetry are broken up by the model's shift of weight on to one leg. This is accentuated by the placing of a hand on his hip, which further lifts his shoulder. This pose is far more natural, and even rather cool.

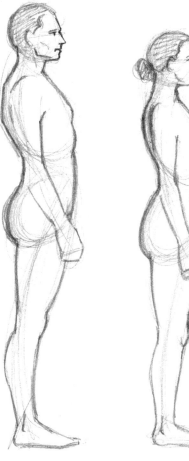

Profile views show more of the body's posture, which is an important element of capturing a personality in the figure. These upright examples demonstrate the slight forward slope of the neck, the pronounced inward curve of the spine and the backward slope of the legs from hips to the ankles. Note also that relaxed arms do not naturally hang straight down, but have a forward thrust.

Having your model place one foot on a small item of furniture or a landscape feature gives the pose a casual, relaxed feeling and makes her seem comfortable in her surroundings. It also provides some interesting angles to draw.

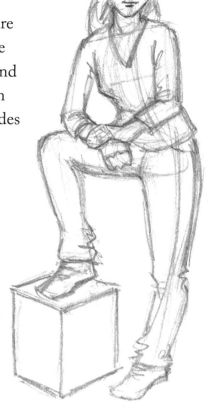

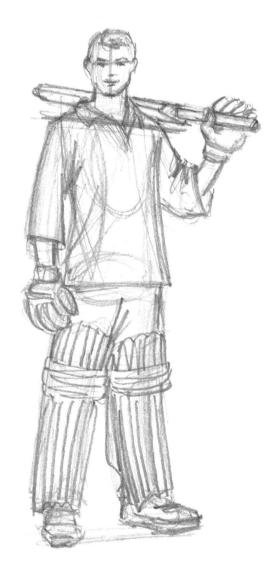

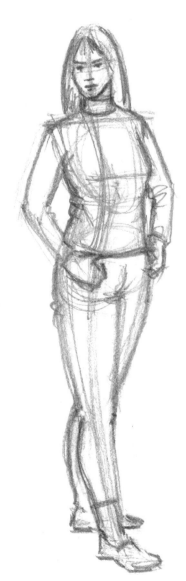

A three-quarter angle of view is usually the most interesting to draw and often quite flattering for the model. A woman's figure can be further flattered by a slight arching of the back; if she keeps her arms away from her sides, it will allow the waist to be visible. Placing the feet so that they are close together also gives the female figure elegance.

Giving your model a prop or outfit will encourage him to come up with his own input, often affecting the way he stands or the attitude he conveys. A man will usually be more flatteringly portrayed with his feet apart.

In sketching this little girl, posture was my main concern from the very start – the confident tilt of the head, the forward thrust of the belly, the raised hip of the leading leg and so on. All of this I strove to capture as I drew the figure in rough, while also keeping in mind the proportions of her figure (around five head lengths).

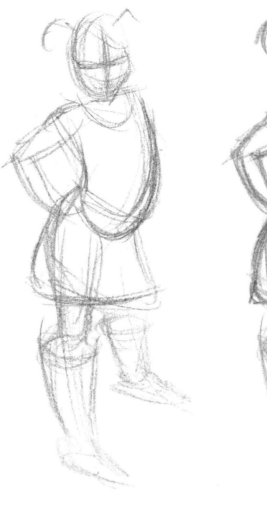

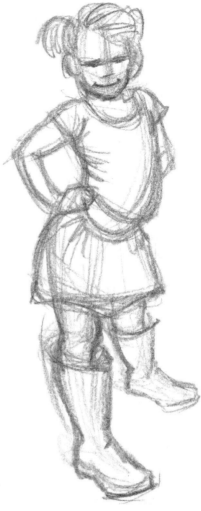

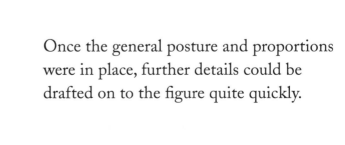

Once the general posture and proportions were in place, further details could be drafted on to the figure quite quickly.

This sketch required a different sort of approach, the pose and figure being quite formal and angular. I first drew a curve running through the middle of the trunk to convey the backwards tilt of the pose. Then I drew the head shape and shoulder line and the angles of the body and arms coming down from the shoulders.

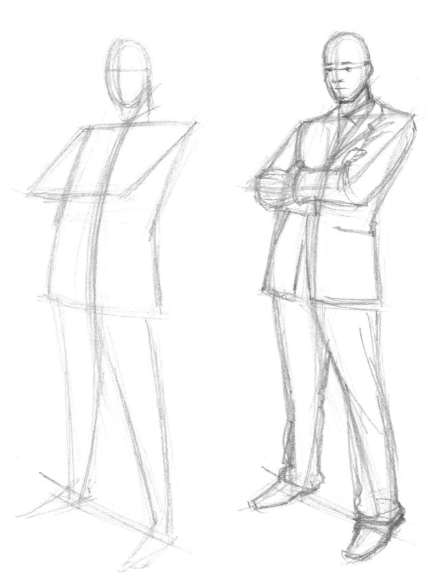

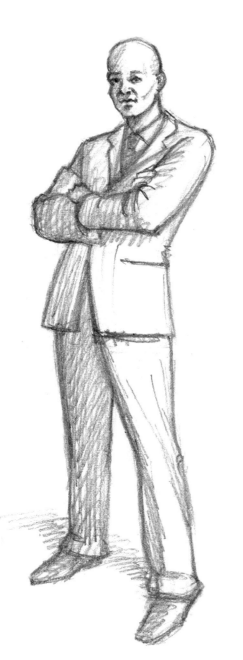

The shape of the jacket made for a convenient mass that I could draw easily. From there down I drew the legs as simple lines at first and carefully observed the angle between the feet on the ground plane. It's important that your initial draft of a figure has the appropriate mass and balance, as well as good proportions.

Eye level

Of the many factors you may consider when drawing a portrait, among the most potent is your choice of eye level in relation to your subject. As the following examples demonstrate, eye level can strongly affect the perception of character or attitude and bring out the more picturesque aspects of a subject.

Looking down on the character can diminish their physical presence and personality. Combined with an appropriate expression, the effect can be endearing or pitiful.

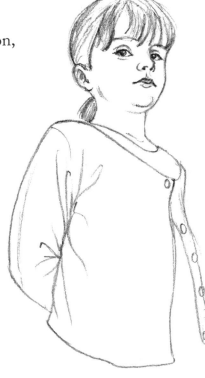

When the subject looks down at the viewer, she conveys an attitude of superiority which may be disapproving or even sinister. This is an angle of view often employed by film directors to affect the audience's response to a powerful hero or villain. It is not generally a very flattering angle of view, especially with older family members because it shows a lot of the jowls.

Here my eyeline is level with the model's, making for a more neutral feeling. This is usually the best angle for capturing a likeness.

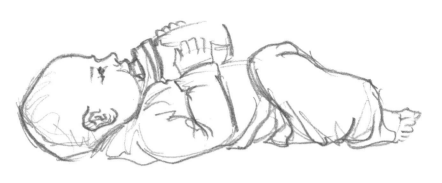

Getting down to the same level as small children allows a glimpse into their world, which is generally more satisfying than the distancing effect of our usual view from above. To sketch my baby nephew from his eye level I had to lie flat on the floor. This viewpoint gave a clear view of his profile.

Extreme eye levels can make for arresting images, showing things in ways that are rarely seen or noticed. Here I stood behind the seated figure and looked down at an almost vertical angle. Some such viewpoints can lead to ambiguities, which make a picture all the more alluring, challenging the viewer to 'complete the puzzle'.

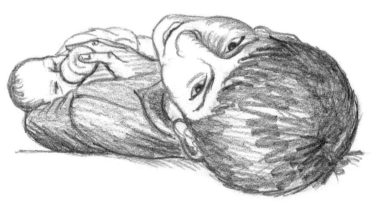

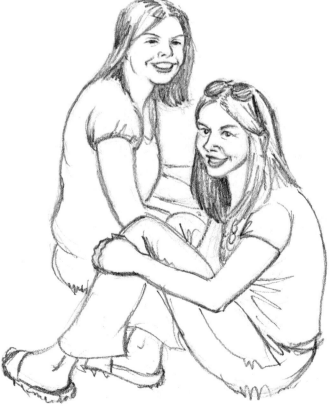

Sometimes raising or lowering your eye level is simply about giving yourself a clear or pleasing view of a subject. I liked the way these girls' poses mirrored each other. By standing on a chair to sketch them, my perspective shifted so that one figure sits above the other, making both clearly visible. Together they form a sturdy triangular composition.

Seated figures

People tend to relax and fall into comfortable poses when they are allowed to sit down, which makes for portraits that are more natural-looking than standing poses. In sitting down, legs will naturally bend, requiring some readjustment of the full-length figure proportions you have learnt. Furthermore, figures may slump, clothing may gather and various body parts may be partially obscured. All these factors may seem like tricky complications, but they are helpful in that they mask some of the difficult elements of drawing bodies and encourage us to look at the figure before us as made up of almost abstract shapes.

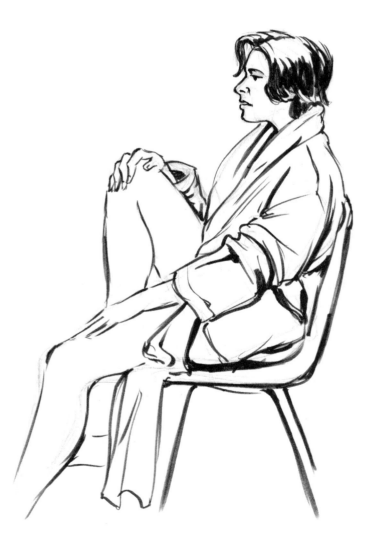

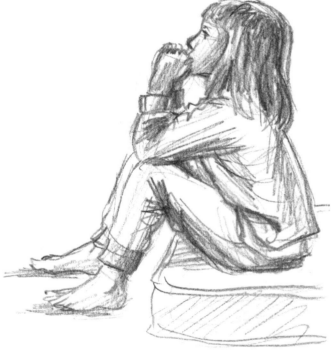

If you can catch people unawares you will get a fresh and honest feel to their pose. Just as we saw when drawing heads, profiles offer the simplest views for building up experience with drawing the full figure.

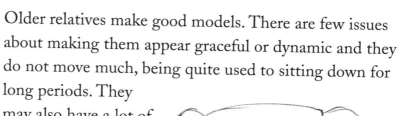

Older relatives make good models. There are few issues about making them appear graceful or dynamic and they do not move much, being quite used to sitting down for long periods. They may also have a lot of time on their hands, so they are unlikely to be impatient with you. If you can catch them having a snooze the task is all the easier, and can make for revealing sketches.

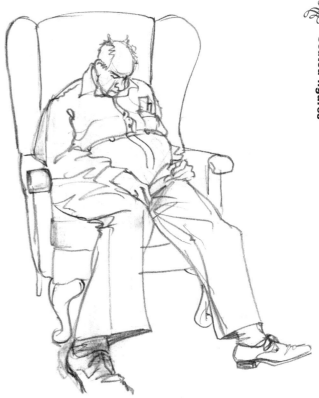

The type of chair your models sit in can have a strong effect on their pose and posture. Drawing the chair is essential if you want to avoid your subjects looking as though they are hovering; it also provides a kind of grid around the figure, which is a great aid to drawing. An armchair provides comfortable rests for the elbows, solving the problem of what a subject should do with his arms. In the drawing on the far right, a high stool gives a sense of scale for the child, allowing his robe to fall freely.

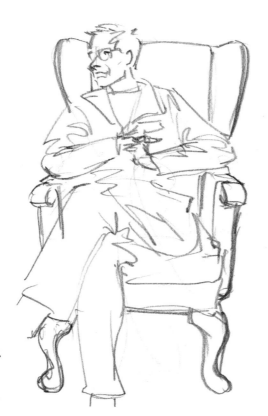

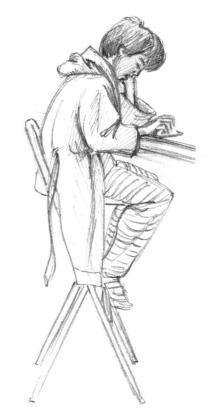

When you have had some practice at drawing seated figures you will find that they can be sketched quite quickly, largely because such poses present many interconnecting angles that help to guide the proportions of the figure and because the folds of fabric mask much complicated detail. Thus you can achieve quite sophisticated drawings and sketches in relatively little time.

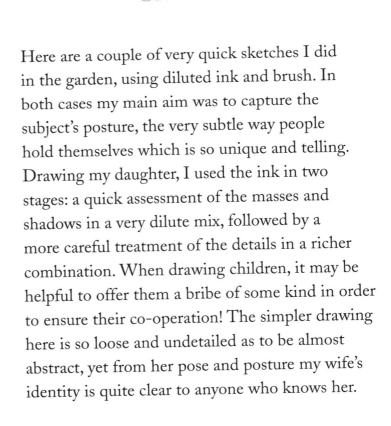

Here are a couple of very quick sketches I did in the garden, using diluted ink and brush. In both cases my main aim was to capture the subject's posture, the very subtle way people hold themselves which is so unique and telling. Drawing my daughter, I used the ink in two stages: a quick assessment of the masses and shadows in a very dilute mix, followed by a more careful treatment of the details in a richer combination. When drawing children, it may be helpful to offer them a bribe of some kind in order to ensure their co-operation! The simpler drawing here is so loose and undetailed as to be almost abstract, yet from her pose and posture my wife's identity is quite clear to anyone who knows her.

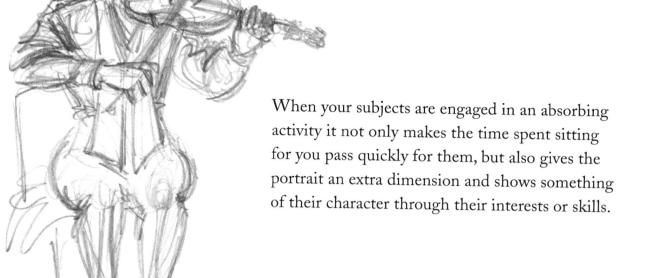

When your subjects are engaged in an absorbing activity it not only makes the time spent sitting for you pass quickly for them, but also gives the portrait an extra dimension and shows something of their character through their interests or skills.

A book is always a good prop to ensure that your subject does not fidget. Playing a musical instrument may present more of a challenge, with the arms and hands moving constantly. You must decide on a position for your model and stick to it. If they move, concentrate on other parts of the figure until they resume your chosen position.

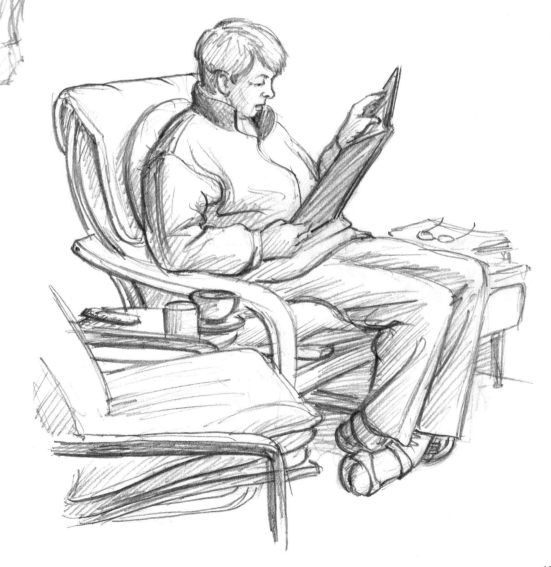

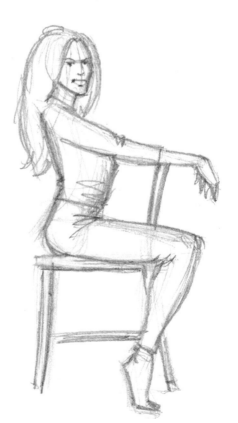

For more formal portraits you may wish to instruct your family as to how they should pose for you. Here are a few pointers to help you to pose your models.

As we saw with standing poses, a three-quarter view is usually the most flattering and elegant angle to work from. Aiming for a triangular form to a pose gives the figure a sense of stability and grace. If your subject perches on the edge of a seat and leans back on one arm, it exposes the torso and provides the drawing with a strong vertical line. Having the model turn her head provides a pleasing shift of plane. A slight backwards tilt to the head brings a feminine feel to the pose.

A chair can be used as a prop for the model to interact with. This pose makes the most of the model's attributes, her slim waist accentuated by the backward curve of her back, which allows her long hair to fall freely. Tiptoed feet elongate the legs, but you may need to provide a support for the model's heels if you want her to hold the pose for long.

A model sitting on the floor makes for another pleasing triangular form. Here the model is male, so I had him lean his head slightly forward to avoid him appearing too feminine. I also ensured his pose felt comfortable and that he was not leaning too far back on his arm or holding his limbs too close to his body. The hand gently resting on the knee is relaxed.

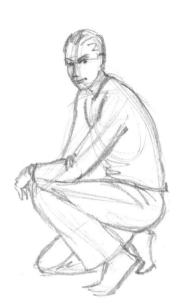

Kneeling can look pleasantly informal. Raising one leg breaks up the symmetry and gives the pose a slightly more dynamic feel. However, poses such as this can be quite hard for a model to maintain for any length of time.

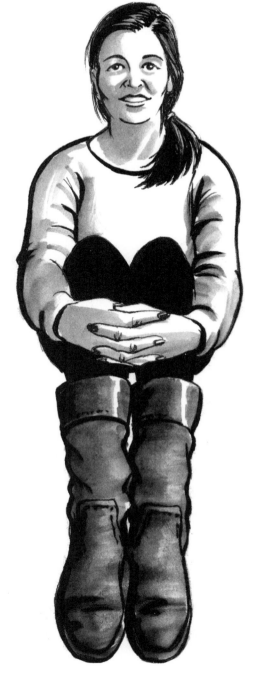

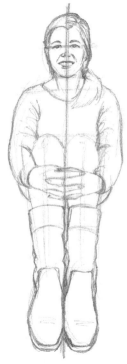

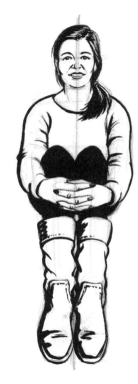

This lady likes to wear boots, so I decided that they would be the main feature here. By sitting close to her, I made the boots appear relatively large, occupying nearly half the picture area. A vertical centre line helped me draft the strict symmetry of the pose.

In setting down the outlines with a black brush-pen, I decided to capture something of the side lighting to soften the pose's symmetry. The heavier left side is balanced nicely by the dark curl of hair over the model's shoulder.

For tone and texture on the boots, I used a grey marker pen swiftly grazed across the surface of the paper for an uneven finish. I left some white highlights on the tops to imply the shine of polished leather. I also used the marker pen sparingly to give the face, arms and hands some tone and form.

A seated portrait

In posing the model for this drawing, I had her sit to one side of the bench to avoid her looking too rigidly arranged. I allowed her to find her own comfortable position. At first her legs were crossed the other way, but this looked a little ungainly. When she reversed their position they immediately looked less awkward from my angle of view and provided the pose with a strong diagonal thrust and a shift of plane from the angle of the torso.

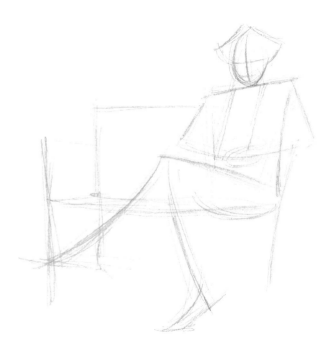

Step 1

My initial concern here was to set down the various angles that made up the pose – the slope of the shoulders, the upward thrust of the thigh, the hang of the lower legs and so on. I also drew the basic shape of the chair, which, as well as being essential to the drawing, forms a convenient grid, helping me to place and proportion the figure within it.

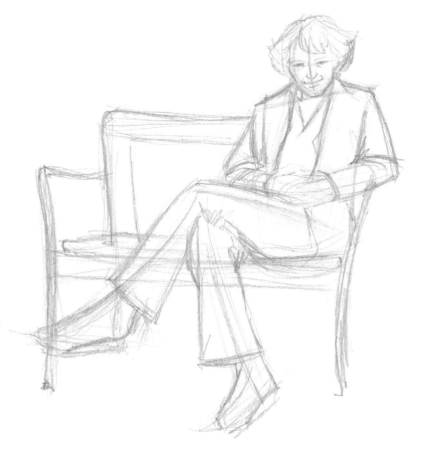

Step 2

I could then draw the masses of the figure on to my grid of angles and proportions, essentially fleshing out the skeleton. Torso, arms, legs and feet all went in as rough shapes, with some basic clothing detail.

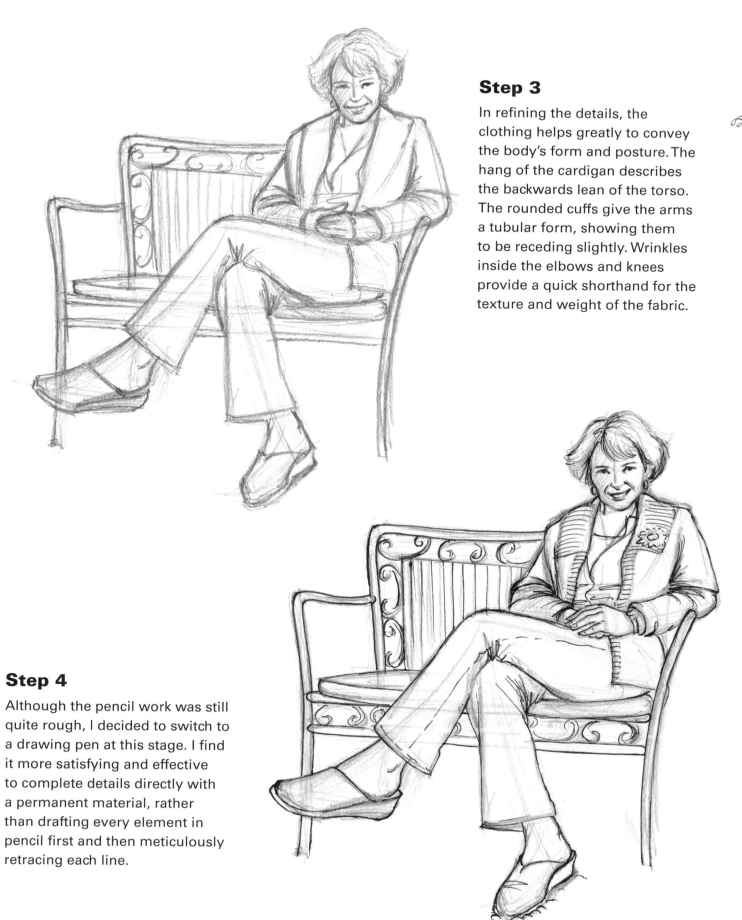

Step 3

In refining the details, the clothing helps greatly to convey the body's form and posture. The hang of the cardigan describes the backwards lean of the torso. The rounded cuffs give the arms a tubular form, showing them to be receding slightly. Wrinkles inside the elbows and knees provide a quick shorthand for the texture and weight of the fabric.

Step 4

Although the pencil work was still quite rough, I decided to switch to a drawing pen at this stage. I find it more satisfying and effective to complete details directly with a permanent material, rather than drafting every element in pencil first and then meticulously retracing each line.

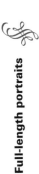
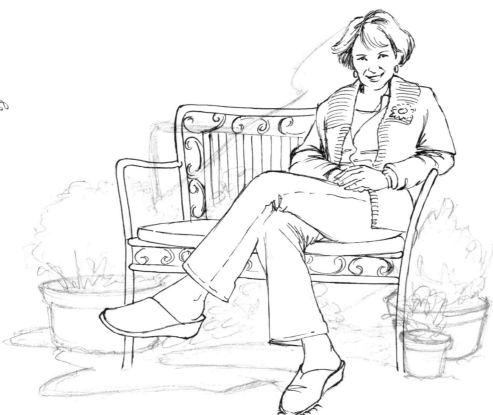

Step 5

After outlining in pen, I erased all the pencil marks. It was then that I decided to include more of the background in this portrait. This lady loves her garden, so it seemed a shame not to show at least some of it. With a selection of the pot plants around the seat, I could create a pleasing triangular composition. Furthermore, the sun was casting a lovely crisp shadow on the wall behind. So I added plants around the drawing and drew the shapes of the shadows.

Step 6

I completed the inking using the same pen as for the figure (0.2mm). I drew the texture of the gravel into the shadows on the ground surface and some suggestion of textures in the plants. I used the pen for some very rough shading in the darkest areas inside the plant pots, and then erased my pencil marks.

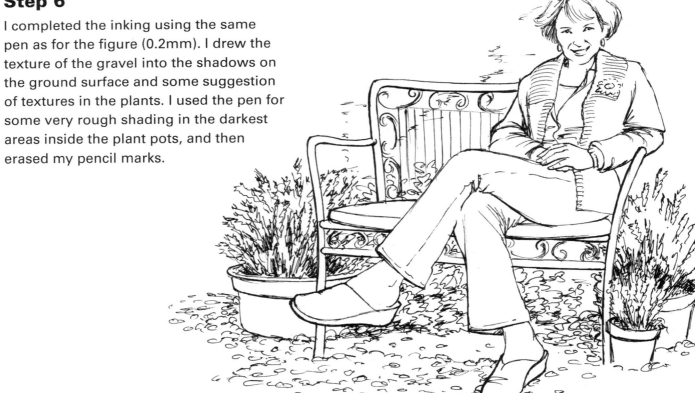

Step 7

I mixed a thin wash of watercolour and used a medium round watercolour brush to paint in all the areas of shadow. Most of this wash was done very quickly and quite roughly, but I took my time on the face and hair and around the white bars of the bench.

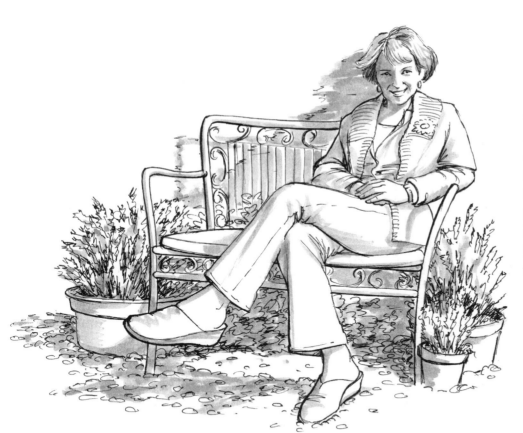

Step 8

I then used a richer mix of watercolour to deepen the shading under the bench and in the plants. I looked at some of the local tones, painting the plant pots darker and working up the shading on the shoes. I darkened her pale cardigan to make it stand out against the white wall, just as the white trousers stand out against the darker background below.

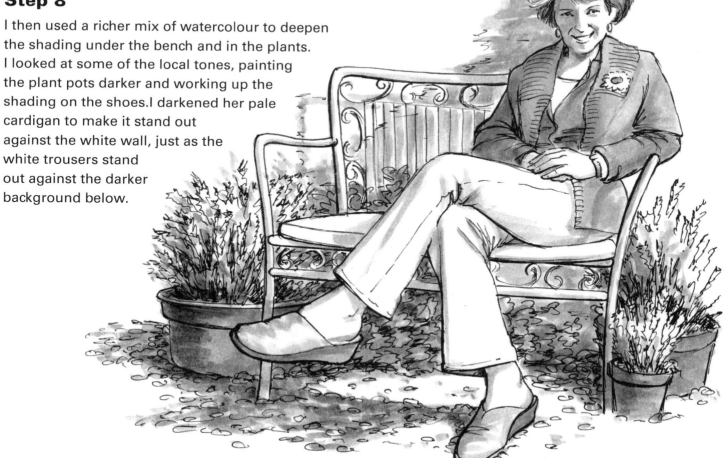

Surroundings and settings

As we saw in the last demonstration, drawing your family against objects or backgrounds that reflect their interests or environment brings an extra dimension to a portrait. With thoughtful selection you need only a small amount of background detail to convey quite a lot about a person and their circumstances. It is usually best to keep background detail restrained so as to support a portrait rather than overwhelm it.

There is virtually no detail at all in the background of this quick ink wash sketch, but the dark shapes provide a strong tonal contrast to bring out the bright lighting on the figure. It tells us that the location is outdoors in full sunshine, an effect supported by the vaguely plant-like form of the marks.

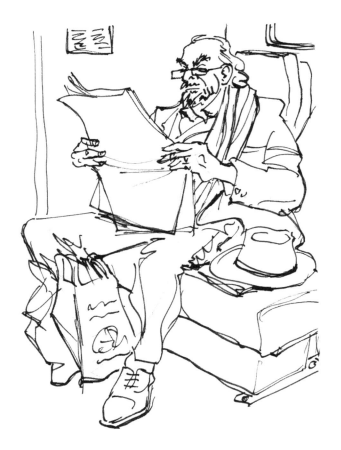

This chap is often seen with his nose buried in a newspaper, so it seemed quite appropriate to draw him this way. The surrounding environment is relevant to his lifestyle and is conveyed with just a few lines which are sufficient to place him in the particular type of seat found in a railway carriage. Other details, such as his collection of bags and his hat and scarf, also add much to his personality.

The environment here is drawn very sparingly, with nothing more than the suggestion of the texture of a shingle beach. The effect is heightened by the low eye level. The absence of other people in the distance makes the beach seem deserted, which adds to the picture's atmosphere, as does the evidence of wind in the girls' hair.

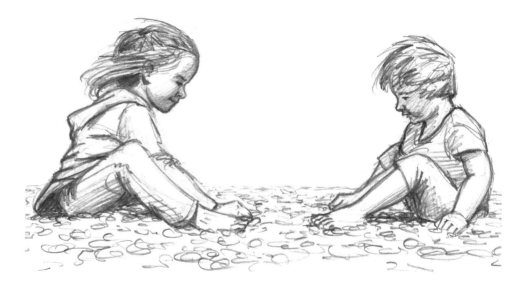

For this more polished portrait I drew the figures sitting in a living room, their bottoms slightly raised on some rolled-up blankets. The background and fishing props are a complete fabrication, added after they had finished posing. Again, just a few details are enough to describe an environment and provide a pleasant backdrop to the portrait.

Taking a completely different approach, I sketched my wife in a café and amused myself by drawing the surrounding details across the facing page of a pocket sketchbook. In this case the environment is cluttered and bustling and demands a certain amount of detail to capture it authentically. As a portrait sketch it stands up because of the relative size given to the main figure.

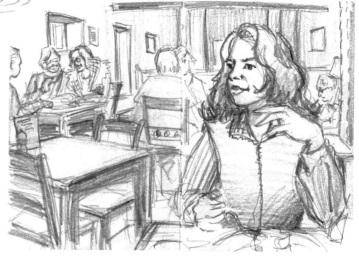

CHAPTER SEVEN

Group Portraits

When you draw two or more family members together, you should give some thought to how they are arranged. Simple principles can be observed in directing such poses, most of which can be demonstrated with two figures. The main thing is to have them interacting in some way.

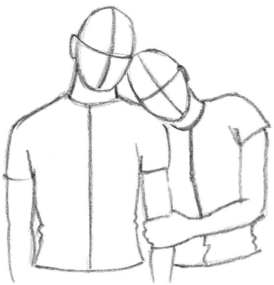

Two figures facing directly forwards can be a very dull pose, but the tilt of a head makes all the difference. As with most arrangements, the aim is to get the heads close together for a sense of intimacy and a pleasing, compact design.

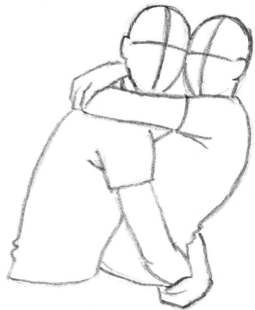

Here the figures are showing yet greater closeness as they wrap their arms around each other. The lean of the figures gives the design a satisfying diagonal thrust.

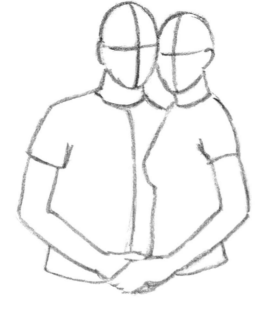

With the figures turned towards each other, their heads are again brought together and a feeling of intimacy is ensured. Holding hands further supports this impression.

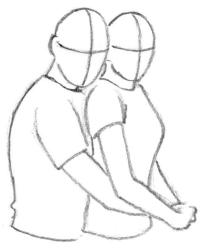

Both figures here are united in facing the same direction. Although they do not face each other, their affection is clear from their embrace and touching heads.

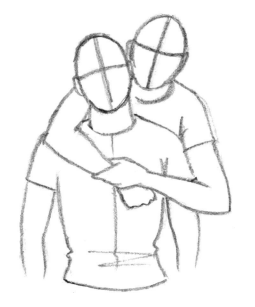

Placing one figure in front of another is a good way to vary the front view and make the composition compact.

It can be an effective device to seat your subjects on different levels, creating a diagonal, triangular composition between the two figures.

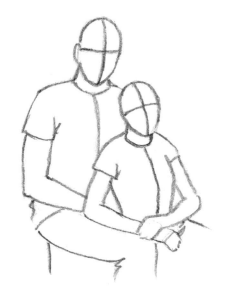

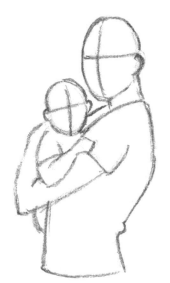

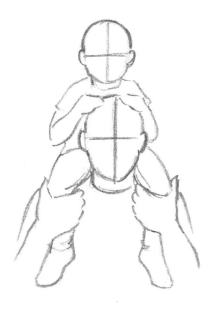

Most or all of these principles can be adapted for use with a child, showing the child held in an adult's arms or in the lap. The difference in size between adult and child presents additional posing options impossible with two adults.

Small babies can look like mere bundles in the arms; if you hold them up to your face, they look awkward and uncomfortable. Turning to the side presents a compact pose that supports the baby firmly as well as conveying an intimate gesture.

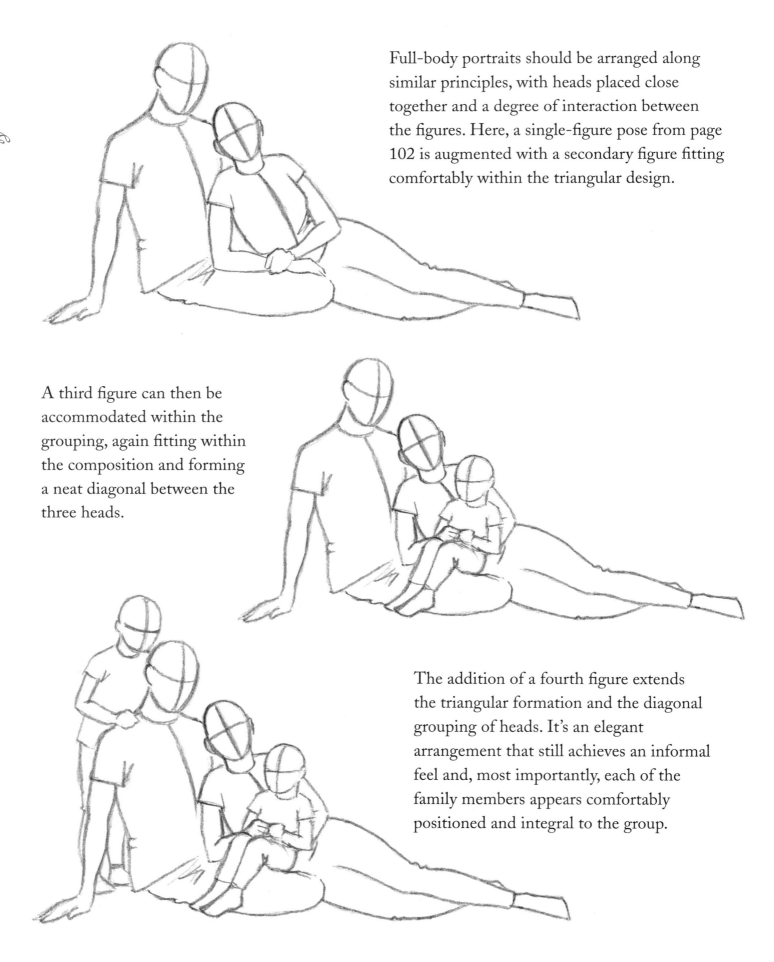

Full-body portraits should be arranged along similar principles, with heads placed close together and a degree of interaction between the figures. Here, a single-figure pose from page 102 is augmented with a secondary figure fitting comfortably within the triangular design.

A third figure can then be accommodated within the grouping, again fitting within the composition and forming a neat diagonal between the three heads.

The addition of a fourth figure extends the triangular formation and the diagonal grouping of heads. It's an elegant arrangement that still achieves an informal feel and, most importantly, each of the family members appears comfortably positioned and integral to the group.

In the same way, a larger and more formal grouping can be arranged by gradually positioning extra figures around a central couple. This pair are arranged in a very formal 'lord and lady of the manor' type of pose, which is somewhat old-fashioned but sometimes appropriate for a desired effect.

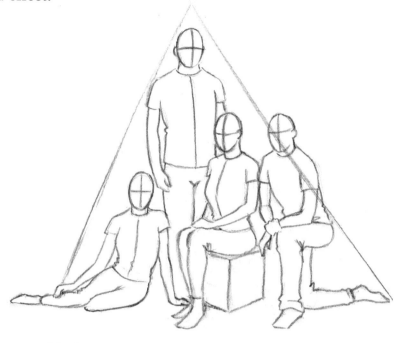

Figures added either side form a classic triangular arrangement and break up the stiffness of the central couple, but the lack of contact between the figures retains a degree of formality.

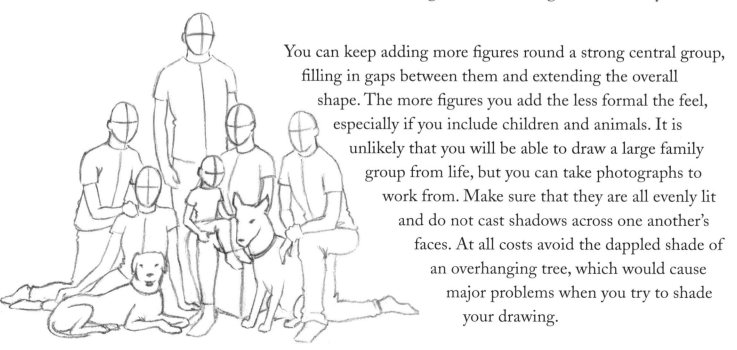

You can keep adding more figures round a strong central group, filling in gaps between them and extending the overall shape. The more figures you add the less formal the feel, especially if you include children and animals. It is unlikely that you will be able to draw a large family group from life, but you can take photographs to work from. Make sure that they are all evenly lit and do not cast shadows across one another's faces. At all costs avoid the dappled shade of an overhanging tree, which would cause major problems when you try to shade your drawing.

A group portrait

With larger groups, particularly those including small children, it is not easy to organize graceful poses and compositions. However, as long as you can get some clear photographs of the group under the same lighting conditions, you can manipulate the design in many ways to create a satisfying portrait.

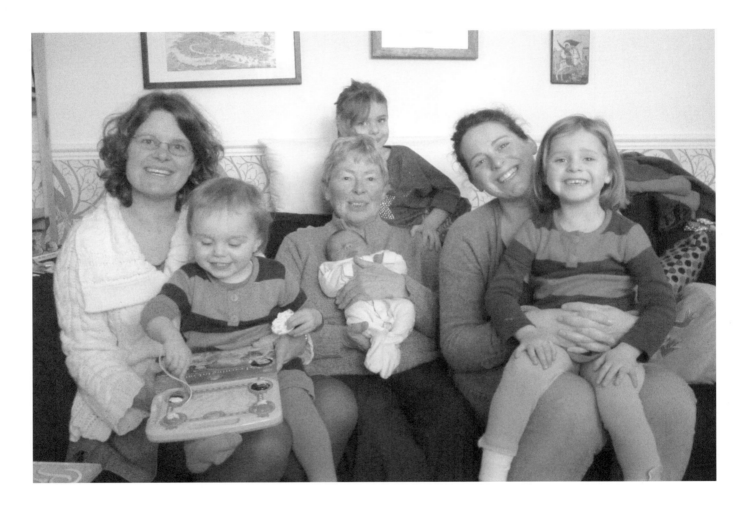

I took several photographs of this group, including at least one clear picture of each face, and selected this one to base a portrait on. As a snapshot it is quite adequate, with everyone looking jolly and comfortable, but for a portrait drawing it has many flaws, including awkward overlaps and an inattentive child.

Step 1

I began my redesign by placing the heads in a more orderly arrangement. My aims were to keep the grandmother and baby strictly central and to group the larger heads in diagonal pairs, bringing some order to the group while maintaining an informal feel. I also wanted to close up the spatial depth between the heads in the photograph, so I drew the shapes similar in size, as if they were all roughly the same distance away from my point of view.

Step 2

With the heads in place, I could draw the rough shapes of the torsos and arms and review the overall shape of the drawing. For the child who was not looking forwards, I referred to another of my photographs.

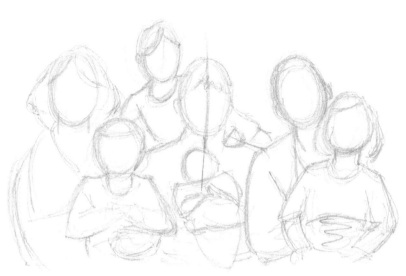

Step 3

I drew the faces very simply at first, aiming to achieve a basic likeness with each in just a few strokes of the pencil. With so many faces to draw it can be a nightmare to capture the likeness of each and a drawing can quickly become over-fussy, so it's always best to aim for simplicity throughout.

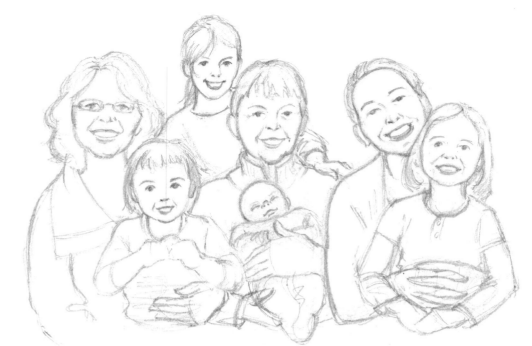

Step 4

I cleaned up the rough marks and guidelines and set about establishing the drawing of all the parts as cleanly and simply as possible.

Step 5

Although I was generally satisfied with the drawing, it had become messy and the paper was quite smudged and dirty. At this point I took the decision to draw it on to a fresh piece of paper, sticking both sheets on to a window and tracing by the daylight shining through. I traced meticulously with a hard pencil and then used a sharp HB to firm up clean, clear outlines, referring constantly to my source photographs. I changed the hair of the lady on the right to a style she more commonly wears.

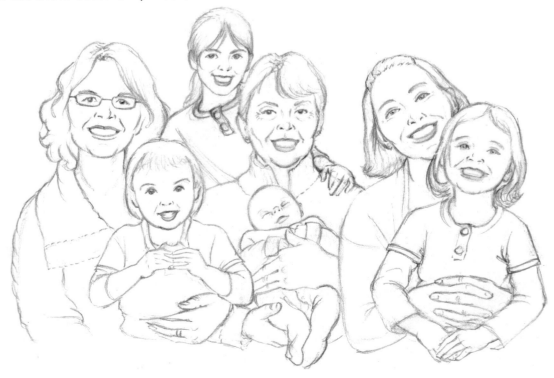

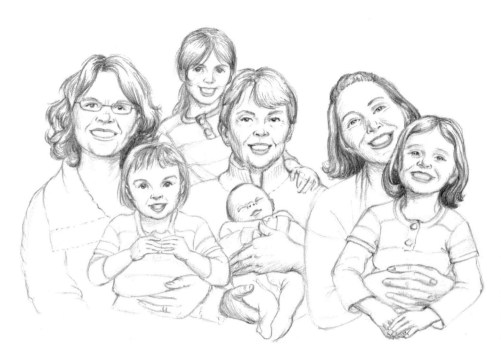

Step 6

To give the picture some form, depth and texture, I set about shading, concentrating initially on the faces. Each head being quite small, I aimed to keep the marks very simple and minimal, using clear, hatched strokes around only the more prominent features and leaving much of the paper white. I decided to dress all three girls in the same style of T-shirt and marked the stripes.

Step 7

In shading the clothing, I veered slightly away from the actual tones of the source photograph for the sake of tonal balance across the picture. I shaded the grandmother's cardigan quite dark so that the baby would stand out against it and shaded the stripes on the girls' T-shirts. I left the clothing of the mothers very pale to avoid making the drawing too dark and heavy.

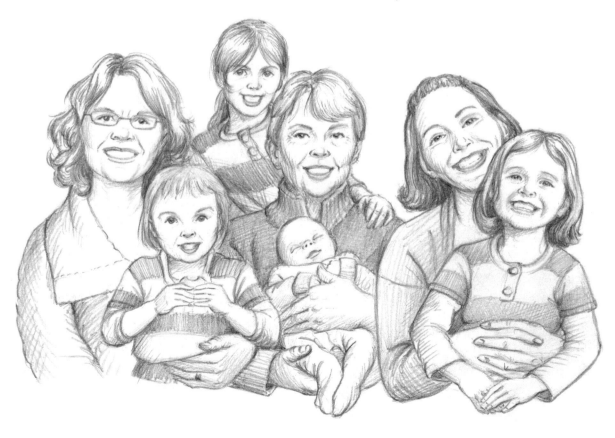

A quirky group portrait

Even though there is a lot of work involved in drawing multiple portraits, they need not be thought of as serious undertakings. For this demonstration I found a photograph of my family and some friends larking about with a collection of silly hats.

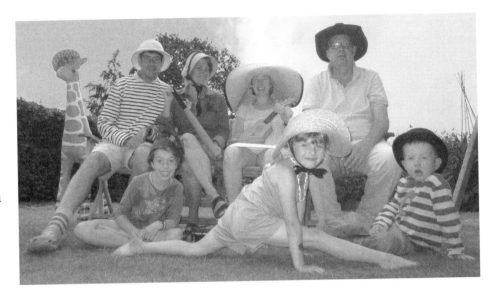

Step 1

Aiming for a complete redesign of the photograph's composition, I sketched a symmetrical triangle in which to reorganize the figures. I started with the foreground girl stretched across the bottom of the picture and worked in layers going back, moving the other children in behind her, compacting three seated figures behind them and topping it off with a standing figure. The heads get progressively smaller as they recede in the picture.

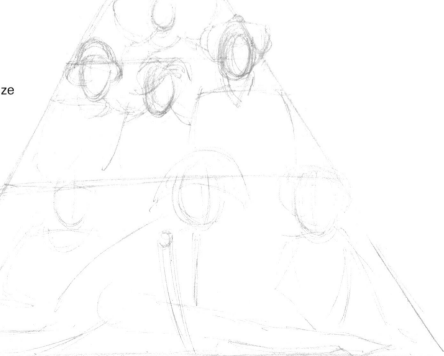

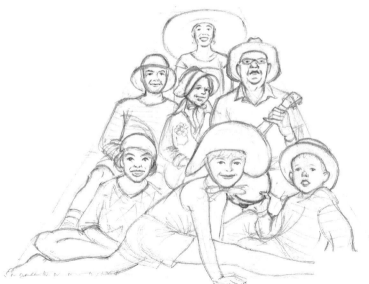

Step 2

With the new composition arranged, I copied the individual characters on to the relevant parts of the drawing at the appropriate size. In doing so, I found some awkward empty spaces so I filled them in with some hand activities, the larger man now taking role of ukulele player and the boy shaking a tambourine.

Step 3

I used a fine drawing pen to outline all the detail and then erased all my pencil marks. The outlines look very weak at this stage, but they are crisp and clean, ready to be worked on further.

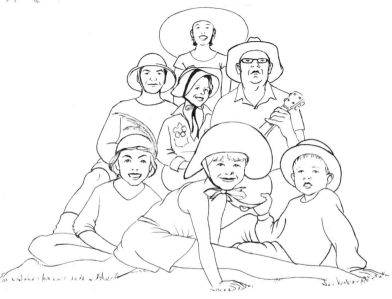

Step 4

For an appropriately bold and uncomplicated feel I chose to continue this portrait in pure black and white with no shades of grey. I first filled in the areas of solid black – a couple of the hats, the bows and some of the hair. When adding stripes, I largely ignored the wrinkles of the cloth, opting instead to simplify them. I strengthened the outlines and then let the needs of the drawing dictate further areas of black and pattern, aiming for a balance of black and white across the picture.

Caricature

The art of caricature, a method that is often vicious and scathing but sometimes gently flattering, has delighted people for many centuries. Essentially it is about exaggerating certain features of a face to bring about a kind of heightened likeness, the results of which are often quite humorous, especially if you know the subject well.

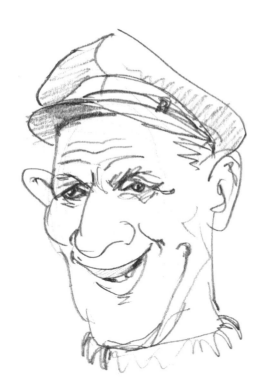

Some faces are so full of character that they seem to be caricatures already! Even so, there is always scope for nudging the proportions slightly, as I did with this jovial skipper, letting his nose and lower face grow larger as I worked my way down the sketch. I did not hold back from drawing all the wrinkles and lines around his eyes and brow, which add to the characterization.

Caricature can also be about simplification and leaving out any details that do not contribute to a person's image. Here I portrayed a keen rugby player in a line drawing that is almost cartoon-like in its simplicity. His stance, costume and hairstyle describe him as much as his minimal facial features.

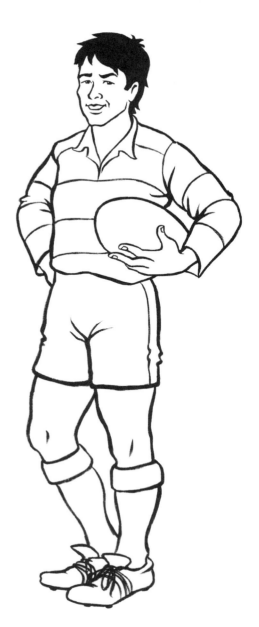

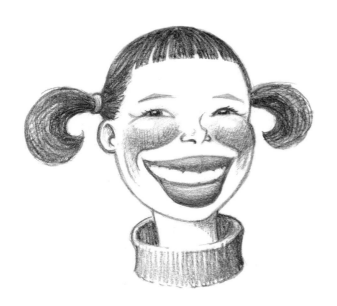

A relatively easy approach to caricature is to disregard any attempt at realism and reduce the face to a set of symbols in a simplified, geometrical drawing style. Here the full lips, upturned nose, rosy cheeks and hairstyle are sufficient in themselves to convey the model's distinctive look without the struggle for a traditional likeness.

This is a more conventional caricature, with the subject's face and expression being redesigned as a goofy version of reality. The small body adds to the comic effect and allows more space in the picture for the important head. This chap was very proud of his car restoration project and it seemed fitting to show him behind the wheel.

It is the body that carries the caricature here. The elongated legs, skinny jeans, messy hairstyle, headphones and characteristically slouched pose describe the subject without his face being necessary at all.

A caricature in charcoal

Caricaturing women is not always easy. Women sometimes object to being made to look ugly or buffoonish in a way that a lot of men don't seem to mind. So it may work well to focus on a positive attribute, such as large eyes, high cheekbones or full lips. Working in a soft-edged medium and using rounded rather than angular marks can also soften the effect. Charcoal has the additional benefit of allowing for remodelling of the face as a caricature develops.

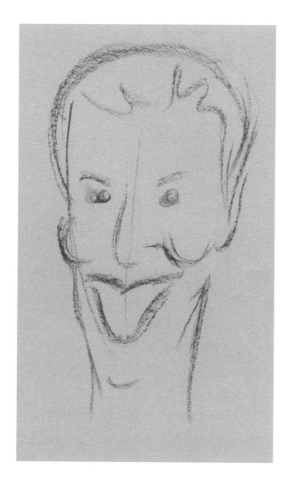

Step 1

For a caricature of my dear mother I wanted to concentrate mainly on her big, genuine smile and her rather long face. I drafted a very rough head with a blunt charcoal stick on toned paper, setting out some general proportions.

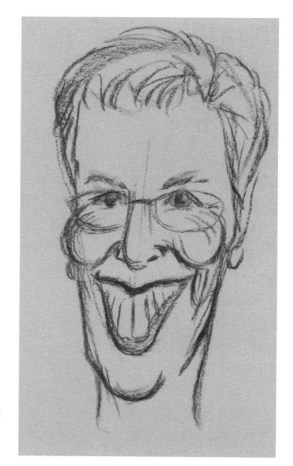

Step 2

In developing the features, I was not too concerned with likeness so much as drawing a reasonably convincing head around the exaggerated proportions.

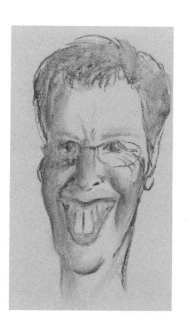

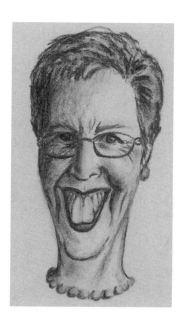

Step 4

I sharpened my charcoal with a knife and set about redrawing the features in detail, with close reference to my source photograph. This stage took some time and required more smudging and some erasing with a pliable putty rubber to make corrections along the way to achieving a good likeness. I then sprayed the drawing with fixative to help prevent further smudging of the charcoal.

Step 3

I selectively smudged the charcoal with a fingertip, subtly correcting the form of the drawing while also laying down a gentle shading scheme based on the lighting of my source photograph. With all the lines softened, it was easier for me to visualize the likeness lurking within.

Step 5

The toned paper then allowed me to add some highlights with a few strokes of white chalk. These do not add greatly to the likeness, but give the portrait some effective sparkle, brightening the complexion and enhancing the drawing's three-dimensional effect. A final coat of fixative spray protected the finished caricature.

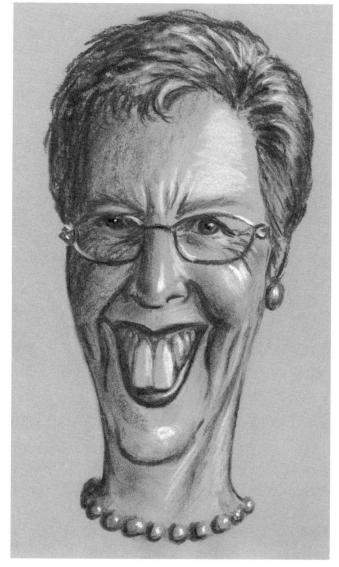

A comicbook caricature

Step 1

My daughter wanted me to draw her in the style of her favourite children's book, which presented me with an interesting challenge. I started by drawing a rough portrait with the intention of greatly enlarging her eyes to fit with the illustration style. It was not very easy to achieve a likeness with such distorted proportions, but after lots of subtle changes I came up with something close enough to work with.

Step 2

My initial drawing being scruffy and dirty from so many changes, I traced it on to a fresh piece of paper and adapted it to fit the desired styling. I restyled the hair and reshaped the neck and shoulder. I also tweaked the outline of the face and reduced the size of the nose.

Step 3

I went over the outlines with a fine black drawing pen, aiming to make each line graceful and unbroken and taking particular care over the eyes.

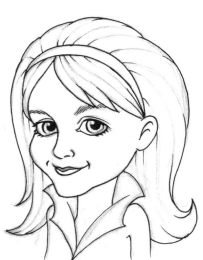

Step 4

After erasing all my pencil marks, I used the fine black pen to refine the pen work, strengthening the main outlines while leaving the facial features more delicately drawn. I made sure that the ends of the strands of hair each ended in a fine point.

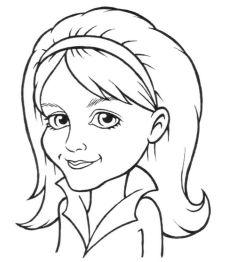

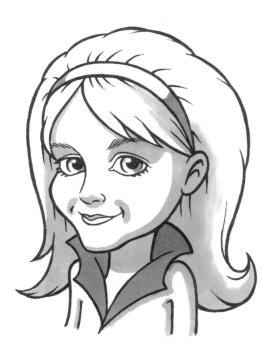

Step 5

To mimic the slick digital rendering of the illustration style, I elected to use marker pens to complete the portrait. These work best if you start with the shading, which I did here using two shades of grey.

Step 6

I covered the whole drawing with a uniform pale grey, working in swift strokes to avoid streaky marks and leaving only the whites of the eyes and a highlight on the headband. Then I drew some stylized texture lines on the hair with a darker grey pen.

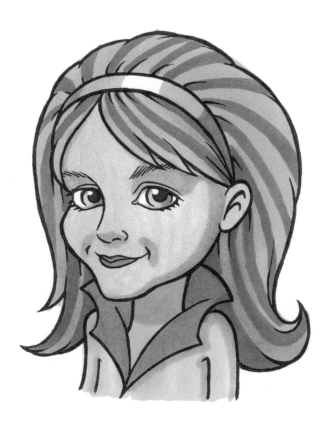

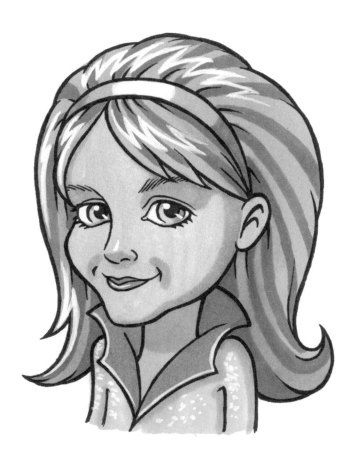

Step 7

I used white ink and a fine-pointed brush to add some highlights on top of the marker pens and to clean up some odd marks around the edges. These highlights give the picture the appropriate shine and are much easier to add afterwards rather than to try working around them with marker pens.

Pastiche

Beyond caricature, there is a whole realm of further fun to be had by adapting artistic conventions or stylings to draw your family members or portray them as fictional or historical characters. Such approaches to drawing are known as 'pastiche' and can take many forms. Pastiche portraits can be highly effective and flattering to the subjects and they are quite easy to do because you will often have a pre-existing design to copy.

To draw my son as a charismatic secret agent, I based the portrait on a classic movie poster, copying the actor's pose, costume and gun. I also needed a suitable photograph of my son to work from. You may have to pose your subjects carefully for such pastiches to get photographs from the appropriate angle in the appropriate lighting conditions. Once the drawing was finished, I used watercolour washes for the face and hand and filled in the surroundings with undiluted black ink.

It was not so simple to draw a baby as a maverick outlaw from the future. Again, I drew the face from a photograph and took the body from a movie poster, but in this case I had to change the proportions of the figure from those of a fully-grown man. I did the outlines in brush and black ink and shaded the figure and background using marker pens.

This lady is drawn not only in the costume of a 1950s housewife but also in the simplified graphic style of the period. The repetition of the cakes' spots on her outfit gives the design a pleasing uniformity, appropriate to the period feel.

I really enjoyed the challenge of drawing my daughter in the style of Picasso, looking at some of his portraits of young girls for inspiration. Over a rough pencil sketch I used a crude bristle brush and black ink to draw the bold outlines and fill in the shapes of solid black, then used a finer brush for a few more delicate features. After erasing my pencil marks, I shaded the grey areas with charcoal and rubbed them smooth with a fingertip. A white pencil worked well over the dry ink to draw some stylized texture into the hair.

Of course, this is only a superficial apeing of a style, tempered by my aim to produce a suitably 'pretty' portrait and quite different from Picasso's intentions with his work. Ultimately, in family portraits it is the subject that matters and your artistic techniques and ambitions should be subservient to the personality of the individuals you draw.

127

INDEX